LEARN TO PAINT

STILL LIFE

ALWYN CRAWSHAW FRSA

D1121085

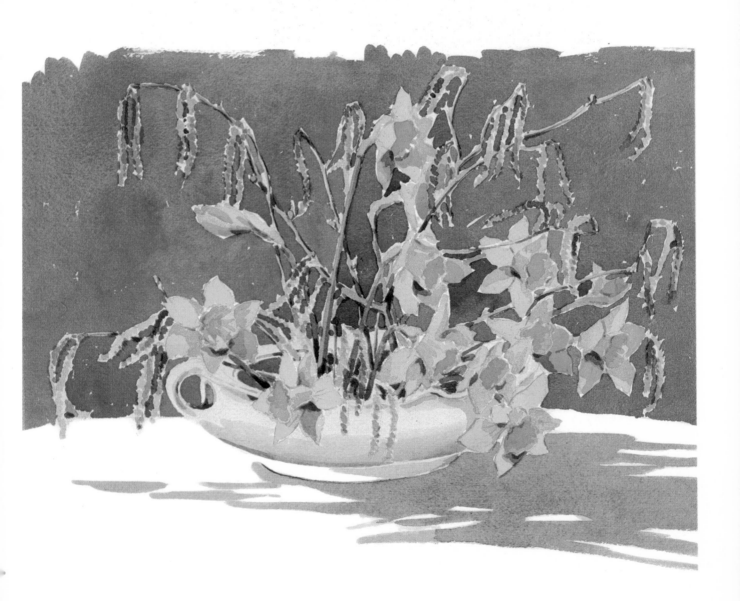

COLLINS

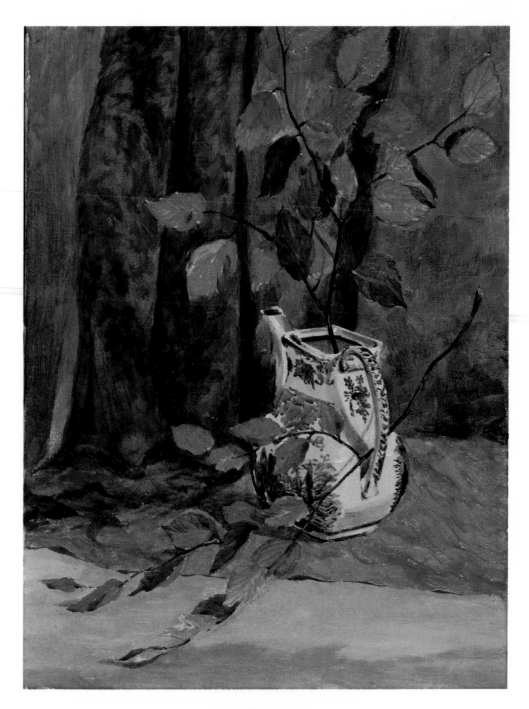

First published in 1984
Wm Collins Sons & Co Ltd
London. Glasgow. Sydney
Auckland. Toronto. Johannesburg

© Alwyn Crawshaw 1984

Editor: Diana Dubens
Designer: Caroline Hill
Photography: Michael Petts

Filmset by Butler & Tanner Ltd
Frome and London
Printed and bound in Spain
by Graficromo, S.A., Cordoba

ISBN 0 00 411790 5

CONTENTS

PORTRAIT OF AN ARTIST
ALWYN CRAWSHAW

Fig. 1
Me painting at home in Devon

Alwyn Crawshaw was born at Mirfield in Yorkshire in 1934, and now lives in Devon with his family. He attended the Hastings School of Art where he studied the many facets of painting in different mediums. Over the years he has become a successful painter, author and lecturer, and is recognised as a leading authority in his field. He does not confine his work to still life, but also paints landscapes and seascapes, working in watercolour, oil, pastel and acrylic. He is a Fellow of the Royal Society of Arts, and is listed in *Who's Who in Art*, in the current editions of the Marquis *Who's Who in the World* and *Men of Achievement*, and in the first edition of *Who's Who in the Commonwealth*. He is also a member of the Society of Equestrian Artists.

This is Alwyn Crawshaw's sixth book in Collins' *Learn to Paint* series. Previous ones covered sketching, working in watercolour and acrylic, and techniques for painting landscapes and boats and harbours.

Crawshaw paints what he calls realistic subjects, including scenes of English landscapes, which have been favourably reviewed by critics, and at times compared with those of John Constable, the best known English landscape artist. Working horses or elm trees are frequently a part of Crawshaw's landscapes, and may be thought of as his trademark.

The popularity of his work spread considerably after the print of his painting *Wet and Windy* was one of the top ten prints chosen annually by members of the Fine Art Trade Guild. Fine art prints of his well-known paintings are also very much in demand overseas. His paintings are in private collections in Britain and throughout the world, and are sold in art galleries in the United Kingdom, France, Germany, North and South America, Australia and Scandinavia.

His work has been exhibited at the Royal Society of British Artists in London, and in several Eastern European countries, including Poland, Hungary and Romania. He has held numerous one-man shows in England at Chester and at Harrods, London's prestigious department store, and also in Germany. These shows attracted the public and critics alike, who acclaimed his paintings enthusiastically. Crawshaw's works have a feeling of reality about them, and an atmosphere which often gives the viewer the impression of having actually been at the scene of his painting.

He has been a guest on radio phone-in programmes, talking directly to members of the public about their painting problems, and he has discussed his techniques on radio and television, national and local, including BBC television's *Pebble Mill at One* and *Spotlight South West*. In addition, he gives demonstrations and lectures to groups and art societies throughout the country.

Alwyn Crawshaw firmly believes that still life is the best way of learning to paint – in fact, most art schools continue to use still life as a beginner's subject – but he also shows just how versatile and fascinating a subject it is in its own right.

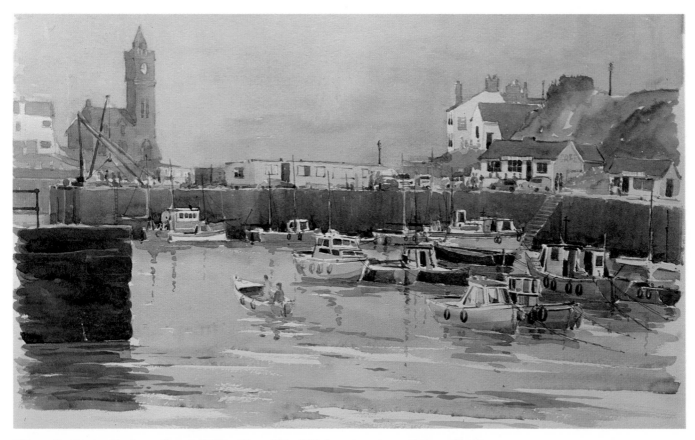

Fig. 2 Porthleven Harbour, Cornwall, 38 × 51 cm (15 × 20 in), watercolour, private collection

Fig. 3 Green Buddha, 51 × 76 cm (20 × 30 in), acrylic. I painted this for my wife, June, on her birthday

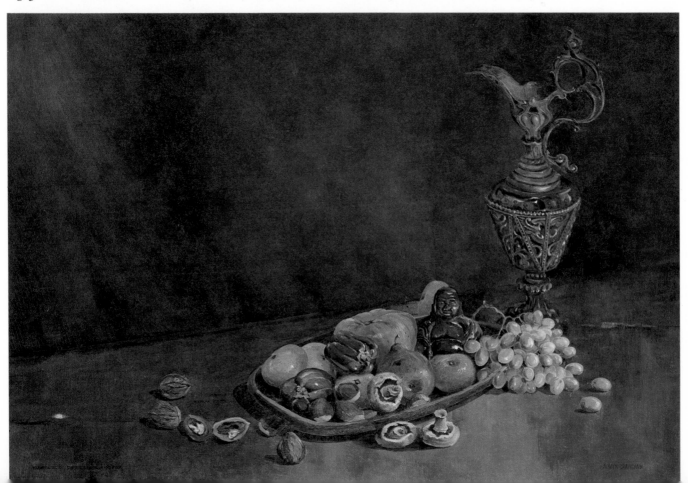

PAINTING STILL LIFE

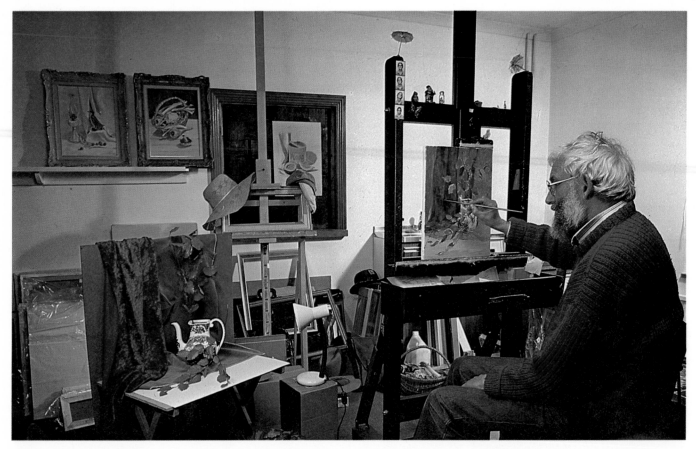

Still life, in my opinion, is the best way to learn the basics of drawing and painting. Unless you are experienced, it is much easier to copy nature and the things around you – in other words paint from reality rather than from your imagination or memory. You then have two options: you can either work out of doors, in the countryside or by the sea, for instance, or you can be indoors and paint still life. An experienced artist will know why working indoors on still life has so many advantages over working outside. The main one, and most important, is that you – the artist – create your own working conditions, and those of your subject. This means that you can work in a controlled environment for as long as you like, and when you like. A painting trip in the countryside could be cut short almost before you have started if the weather deteriorates. Even worse, you may have just settled in a suitable spot only to discover that a herd of frisky cows can have a very disruptive effect on your painting!

What I am saying is that, for a beginner, it is better

Fig. 4 Painting indoors can be cosy and relaxing. Here I am comfortably set up in a quiet corner of my studio

to spend time painting at home at first, rather than venture out into the 'unknown' to draw the first creative pencil lines and brush strokes. Yet still life is versatile enough to offer a more advanced student a wide variety of subjects to work from when weather conditions or personal commitments limit the choice. This applies to any housebound artist. In addition still life is a subject in its own right, which has been painted by the masters for centuries in every medium.

So, what is still life? I have had to give this question a lot of thought, because it is a subject that I have taken for granted ever since my first attempt at still-life drawing at art school. Although I have no clever explanation, I can simply offer the interpretation that I have held throughout my painting life, that a still life consists of one or more inanimate objects, usually placed together by the artist (although not always),

and positioned in such a way as to be an inspiration to work from. The usual place to paint a still life is indoors. The word 'still' obviously implies that what you are working on will stay in its given position, but there is a limit, of course, to the length of time you can spend on a particular painting if the subject is perishable. 'Life', in this context, means that you are working from reality, as opposed to pictures, photographs, imagination or memory.

Traditionally subjects chosen are fruit, vegetables, fowl, fish, bowls, brass, copper and pewter plates, mugs and ornaments. These would be arranged on a table or on cloth of some kind, or against a background of a wallhanging. I can only assume that before gas and electricity was available, the group would have been set up near a good source of light, such as a window and, of course, painting would have been restricted to daylight hours only. This would mean that the most important aspect of setting up a still-life subject – the light – was not under the artist's control, as natural light changes throughout the day. Nowadays we take for granted being able to control light at the flick of a switch. We have light whenever we want it and, more important, as far as artists are concerned, it is constant.

Over the past few years artists have been moving away from the traditionally accepted subjects for still life painting, and in the chapter on choosing your subject I go into this in more detail.

For beginners and those who are learning to paint still life as a step towards painting other, perhaps more complicated subjects, such as landscapes and seascapes, I have arranged my subjects into three distinct areas. This will lead you gradually from inside your home to the outside, where you will have to learn to work with the elements and other unpredictable factors. Just as important, however, this grouping of still life subjects will give you more scope, whether you are a beginner or the most advanced still-life student. Below are my three categories.

Total-control still life A group of objects that you arrange to meet your artistic requirements *indoors*.

Semi-control still life A group of objects or an area *indoors* positioned by chance or as a result of everyday life, for instance a table covered in the aftermath of breakfast, or the corner of a room.

Minimal-control still life A group of objects or an area *out of doors* also positioned by chance or as a result of everyday life, such as gardening tools leaning against a wall.

Total control is the most commonly accepted way of setting up and painting a still-life group. I call it total control because that is exactly what you have when

Fig. 5 A still life I painted at art school at the age of 16. 36 × 30 cm (14 × 12 in), watercolour

you set it up. You choose your subject, where, when and how you will work, where the light comes from, and how comfortable you are. Because you control all these things, your subject is fixed and invariable for as long as you want – for the next five years if you like. (Watch out though for fruit and veg or flowers!)

Semi control describes a group arising by chance or as a result of everyday life. It is not something planned by you. If you wanted to set up a group of, let us say, breakfast items, you would gather everything together and set it out on a table; but it would look contrived and unnatural. The answer then is to finish breakfast, leave the table as it is, then pick out a section and paint it. It will turn out very well. I can imagine some of you thinking, 'I can't paint in the kitchen', or 'I can't leave the table uncleared all day' and 'what about the smell of turps in the kitchen?'. Well, perhaps you would be

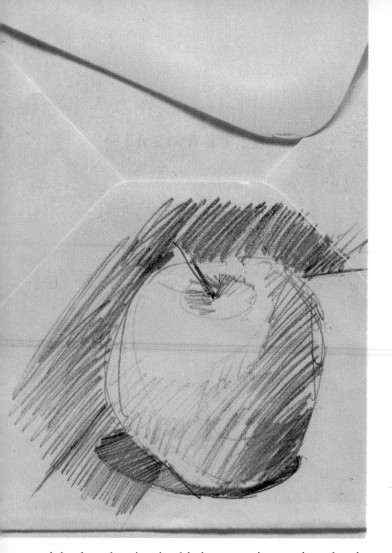

Fig. 6 Apple on old envelope, drawn in pencil for practice. You try!

subject of one or more inanimate objects, that stays where it is, and sufficiently of interest to the artist to be painted) there is absolutely no reason, apart from not having complete control over the subject, why a still life can't be painted outside. Naturally, having said that it would be like opening the flood gates as far as subject matter is concerned, but we must be sensible about what we choose, or we could paint a derelict barn, a parked car, or a long brick wall, and call each one a still life. I suppose all subjects have boundaries which overlap. For instance what would a scene of the sea with cliffs, fields and trees be – a landscape or a seascape? A painting of a person on a beach could be a seascape or a figure painting. So to give you guidelines, I mean interesting groups of objects found around the house or garden. The main reason that you have only minimal control is the weather. It could be windy, cold, rainy or any other adverse condition, which might cause discomfort and spoil your concentration – and of course, the light, is also variable and totally beyond control!

If you now take the three groups in sequence, you can see that exercising total control teaches you to paint in the best possible conditions that an artist could wish for. Semi control becomes a little more difficult, and often entails working in partially unfavourable or uncertain circumstances, and minimal control takes you outside the house as a step towards painting in the 'great outdoors'. This is a natural sequence and if followed the next stage would be to learn to paint landscapes, seascapes, and so on. It is the way I was taught at art school: still life first, then work out of doors. On page 7, **fig. 5** is a still-life exercise I did at art school when I was sixteen years old. I never thought then, that I would be showing that painting to the world, nearly thirty-four years later, and neither did my tutor!

I am not writing this book with the intention that you use still life solely as an aid to painting out of doors, but if you are a beginner, and eventually you want to paint landscape, it is an ideal way to start. I hope that the still-life painters among you will be inspired by what I have written to experiment with new subjects, and that you will be patient if I am trying to guide less experienced students along a path that you already know.

When I was writing about painting landscapes, boats and harbours, and sketching, I had a problem in deciding which funny incident, or which experience, to write about. Painting out of doors is so unpredictable, and of course, the unexpected frequently occurs. More recently I have been sitting with a pen in my hand trying to recall a funny incident which relates to working on

right, but the aim, in this instance, is to paint what is natural and actually there. Perhaps you could try a corner of the sitting room or a table with flowers in the hall – just whatever is around you that inspires you.

As you can imagine you would not have full control over your subject and working conditions. Some of your family might be walking around, between you and your subject, or they may be passing your painting position at critical moments. The light source may be daylight through a window and, naturally, this would change. Your position could be cramped, if you wanted a particular view, and so on. There are many things to distract you, so let me advise you at this point always to ensure that you are comfortable when you are working – there is enough to worry about without being uncomfortable as well.

The last important factor of the semi-control still life is that the subject can be much larger than the usual group of objects set out on a table, as in the total-control group. This will suit some people, as we all work to the scale which suits us best individually. For example a small still-life group will not inspire some students as much as painting, say, a corner of the kitchen.

Minimal-control still life is exactly the same as the previous group except that it is done out of doors. If you think about my definition of still life (namely, a

still life, but I had difficulty in thinking of any. One incident did come to mind though.

Last summer I had put two fish in the deep freeze to keep for a particular painting I had to do in oil colours. The day I was going to do the painting, I was ready to start but had forgotten to take the fish out of the freezer. 'No problem', I thought, and put them in the micro-wave oven. Unfortunately, I didn't set the dial to 'defrost'. By mistake I had put it on 'high', so the fish were left in for too long. When I took them out the smell of half-cooked fish was awful, in fact, it was so strong that it even overpowered the smells of turpentine and oil paint in the studio. I had intended to do a quick free-style painting of the fish, so the only consolation was that the unpleasant smell encouraged me to achieve a very quick, free-style painting!

Except for the occasion when I was at art school, and used a teapot as part of a still-life group, which unfortunately was needed when I was only half-way through the painting (yet another unfinished masterpiece!), the fact that I am only able to recall one story of mishap, really illustrates the advantage of having so much control over a painting. The possibility of having a trouble-free subject to learn to draw and paint from is what makes still life so valuable. It is also the way I was taught. At first I considered that the items we had to draw and paint at art school were very uninteresting, until one day when I could see that my painting started to resemble the thing I was copying and I became very excited and inspired. Remember that you are creating something, and whatever it is, when you begin to get to grips with it, a spirit of achievement surges inside you, and you become inspired by your ability. It doesn't matter whether the thing you are painting is an unattractive matchbox, or a bowl of colourful fruit. What does matter is the pleasure you have when you are creating an image on your paper from something three-dimensional. It is a fantastic feeling.

When writing a book like this, I become excited thinking of all the tips and advice that I could give you if you were sitting at my side. For instance, if you are doing nothing and you have a pencil and a scrap of paper, practise drawing. In **fig. 6** I drew an apple on an old envelope to show a student how to obtain form simply by shading with a pencil. It is simple and informative, so you have a go. However, in a book it is difficult to make learning flow entirely in sequence without the help of conversation, so the points that I make are spread throughout. I suggest, therefore, that you read the book through before starting any of the exercises. If still life inspires you as much as it does me, then it will be difficult for you to read it all before attempting to paint, but please try, it will help you to understand your subject before you start painting.

Fig. 7 Painting a still life in my studio

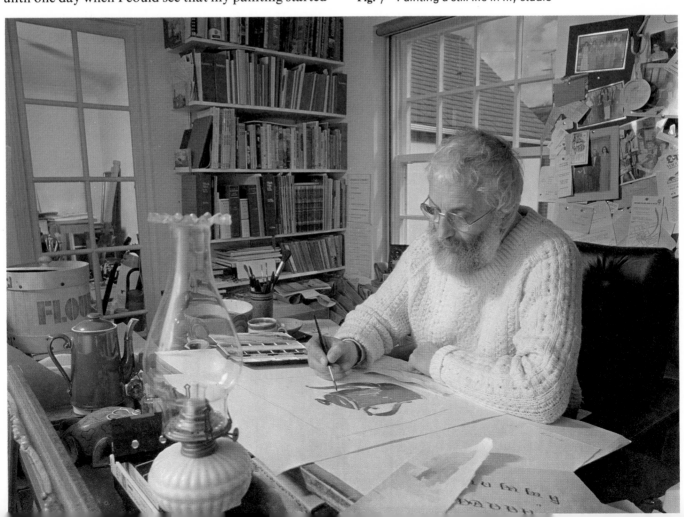

WHAT EQUIPMENT DO YOU NEED?

The equipment you need for painting a still life is no different from that required for any other subject. You can manage perfectly well with the right basics, or you can fill a room with equipment - it's up to you. I suggest you buy the best quality materials that you can afford; it makes working easier and you can produce better results. A selection of materials for acrylic, oil, pastel and watercolour painting is illustrated in **fig. 8**, and there is a key below. I have chosen for you a set of materials containing the basic requirements for each medium, and these are illustrated on pages 12 and 13. I used these sets for all the work in this book.

Watercolour You can buy in tubes, in half or whole pans of colour, individually or in boxed selections. I do not advise beginners to use the tubes because it is difficult to control the amount of paint you have on your brush. The colours I use in this book are: Payne's Grey, Burnt Umber, Hooker's Green No. 1, French Ultramarine, Crimson Alizarin, Yellow Ochre, Coeruleum Blue, Burnt Sienna, Cadmium Red, Raw Umber, Raw Sienna, Cadmium Yellow Pale.

You can start with as few as two brushes: a size 10 and a size 6 round sable (see **fig. 12**). In general, you get what you pay for, so try to buy some sable brushes even though they are expensive. You need a paintbox with 12 whole or half pans of colour (the one illustrated holds whole pans), HB and 2B pencils, a kneadable putty rubber (this type will not smudge), a drawing board with watercolour paper or a watercolour sketch pad, blotting paper, a sponge and a water jar. I suggest you also have a tube of white for when you want to mix an opaque paint - I like Designers' Gouache.

Acrylic There are several types on the market, but the two I use are Standard and Flow Formula. Standard Formula is similar in consistency to oil, and is ideal for palette knife work. Flow Formula (as its name implies) flows, is better applied with a brush and it takes a little longer to dry. I prefer Flow Formula, and I have used it to do most of the acrylic work in this book. You can also buy texture paste to help build up a heavy impasto

Fig. 8 (*Right*) materials for painting in watercolour, acrylic, oil and pastel, with key (*left and below*)

a canvas board
b brushes
c paint rag
d oil painting case, oil colours, gel medium, turpentine, linseed oil, brushes
e oil painting palette, dippers, palette knife, varnish, light drying oil
f canvas, charcoal
g acrylic primer, mediums, texture paste, gel retarder, colours, Staywet palette
h brush case
i watercolour boxes, sponge, mapping pen, sable brushes
j drawing board, paper, black waterproof ink, watercolour pad, pencils
k kneadable putty rubber, mixing palette, blotting paper, White Designers' Gouache
l fixative spray
m box of 36 Pastels for Landscape
n pastel paper and sketch pad, soft dusting brush, pastels

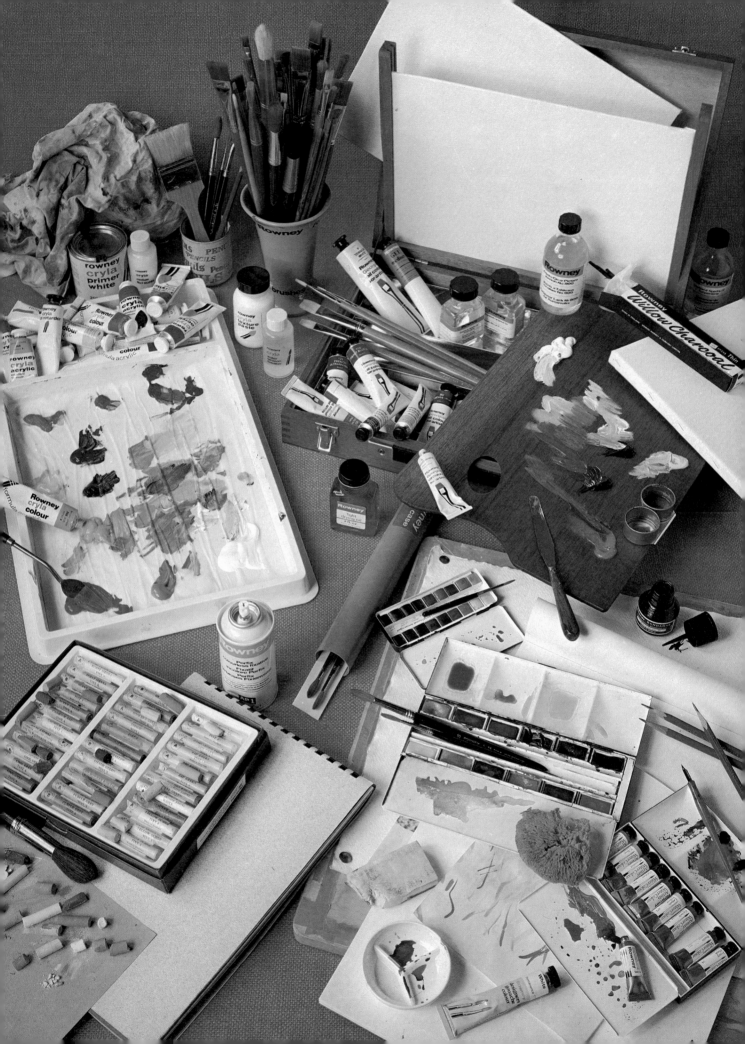

(a thick application of paint). The colours I used are: Coeruleum Blue, Bright Green, Burnt Umber, Raw Umber, Cadmium Yellow, Cadmium Red, Crimson, Ultramarine, Raw Sienna, and White.

I used six brushes for the exercises in this book (see **fig. 12**): Series 233, flat nylon brushes, sizes 2, 4, 6 and 12, a no. 6 round sable brush, and for very thin line work, a Series 56, size 2 sable and ox brush (not illustrated). I recommend that you use a Staywet palette; it prevents your paint from drying out on the palette, and you can use gel retarder to keep the paint wet longer once it is on the canvas. As a painting surface (or ground) you can use paper, board or canvas (board and canvas are illustrated, see **fig. 8**). An HB pencil, kneadable putty rubber, a rag and water jar complete the set.

Oil You will need a box in which to carry your paints around. The one illustrated, which can be bought empty or complete with materials, can carry all the equipment you need, except a rag, and it also works as an easel which you can rest on your knees. However, an old hold-all or a small suitcase will do just as well instead. The brushes are Series 123 bristle in sizes 4, 6, 8 and 10, and a size 6 round sable. You will need a palette knife, purified linseed oil, turpentine, gel medium to speed up drying of the paint, canvas board, palette, dippers for holding linseed oil and turpentine, an HB pencil, a kneadable putty rubber and some rag.

The oil colours I used are: Cobalt Blue, Cadmium Red, Cadmium Yellow, French Ultramarine, Viridian, Crimson Alizarin, Burnt Umber, Yellow Ochre, and Titanium White.

Pastel There are over 50 colours, and each one is available in several tints, amounting to nearly 200 in all. Rowney pastels are graded from tint 0 for the palest to tint 8 for the darkest. The best way to start is with a box of 12 or 36 Artists' Soft Pastels for Landscape. The pastels from these two boxes are the only ones I used for the exercises. When you are more accustomed to them you can buy different tints, colours or refills as you need them. (The box illustrated in **fig. 13** contains 12 colours.) You will need some paper or a pastel sketch pad with a selection of coloured sheets. You will also need fixative to prevent your colours smudging, a bristle brush for rubbing out areas of pastel, a kneadable putty rubber, an HB or 2B pencil and a piece of rag for cleaning your hands.

Brushes I believe the most important tool that an artist uses is his brush. If you want a particular effect in your painting, whether bold or delicate, your brush dictates the result. Therefore I cannot stress too much the importance of buying the best that you can afford. In the beginners' basic painting sets listed on these pages I have suggested materials for you to start with. The series numbers refer to the Rowney catalogue and will

Fig. 9 Watercolour

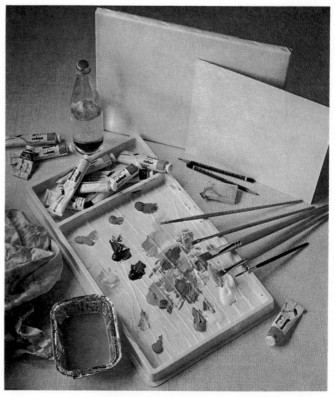

Fig. 10 Acrylic

help you to identify the different types of brush. In **fig. 12** there is a selection which shows you the various shapes, types of hair and sizes. Each series varies in price, but a Rowney Series 34 is a good hard-working round sable brush in the middle price range. Another brush I recommend is a Rowney Series 56, size 2, which is ideal for thin line work. All the brushes are reproduced here actual size. Those illustrated in **fig. 12** are round sable brushes in the range of sizes from 00 to 12, but some series have additional sizes, such as nos. 9, 11, and 14.

Always take good care of your brushes and they will last well. This doesn't mean you must keep them in a glass case and look at them. You should work them – and hard - a good brush can take plenty of use.

Paper There are too many types of paper for me to describe them all in the space available here. If you are mystified by the names of papers I mention, then ask someone in an artists' supply shop to help you.

Equipment is a very personal choice, and your likes and dislikes will emerge through hours of practical experience and experimentation. I know it is difficult for a beginner to have the knowledge, or even the courage, to go into a shop and buy suitable materials, but all those shown here are of the best quality available and you can buy them from any good artists' suppliers. I hope that by following my suggestions you will have one thing less to worry about.

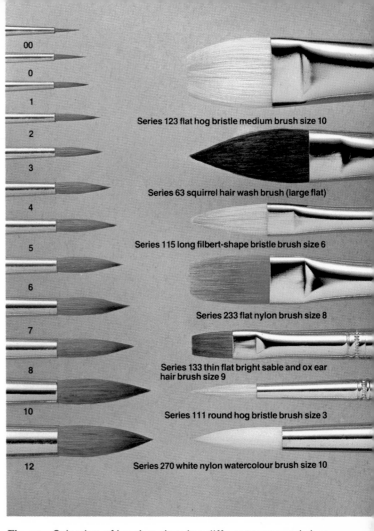

00
0
1
2
3
4
5
6
7
8
10
12

Series 123 flat hog bristle medium brush size 10

Series 63 squirrel hair wash brush (large flat)

Series 115 long filbert-shape bristle brush size 6

Series 233 flat nylon brush size 8

Series 133 thin flat bright sable and ox ear hair brush size 9

Series 111 round hog bristle brush size 3

Series 270 white nylon watercolour brush size 10

Fig. 12 Selection of brushes showing different types and sizes

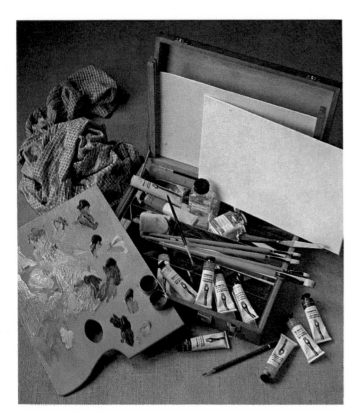

Fig. 11 Oil

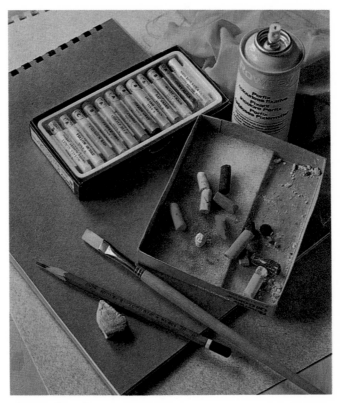

Fig. 13 Pastel

13

CHOOSING YOUR SUBJECT

In the first chapter I discussed various subjects that could be used for still life and the three different categories that I put them in, but how do you choose your subject?

There are two important basic rules. First, *don't go for something too ambitious*. If you decide to set up a large bowl of fruit with apples, oranges, grapes, bananas, pears, and topped with a pineapple, it would look very inviting for you to paint, but if you are not capable of painting a complicated subject like that, it would be a disaster, you would be disappointed in yourself and it might even put you off painting altogether. The answer is, don't try to run before you can walk. Set up, say, just an apple to start with, and try to master that. The chances are you will succeed and be pleased with your results.

The second rule is that *you must be inspired* by the subject you have chosen. In the same way that you would only paint a landscape that you find attractive, you must only paint a still-life subject that appeals to you. This doesn't mean that every part of your painting must be exactly what you want. For instance, if a bowl of fruit on a polished table inspires you, you may find the table difficult to paint, in which case you must work hard at the table. It can't be ignored as it is part of the overall picture which inspired you. In most paintings you will find certain areas are easy to capture, and others that you have to struggle with to get the results you want. Don't worry. You won't be the only one – even professional artists have these problems.

There is nothing I find more frustrating when I am painting a still life and I am happy with my results at a certain stage, then I come to what I had considered to be the easy part, say, a fold in a piece of material. At that point I might have painted any number of items which I thought would be difficult, only to discover that I can't get the fold to look right. This is where patience and persistence comes in if you are not to spoil a good painting. Persevere and it will come right in the end. If it doesn't then perhaps the subject was too advanced for you, so slow down, and concentrate on small, simple groups.

The tendency with still life, as with all painting subjects nowadays, is to break from tradition and try to find new subjects or new ways of dealing with the old ones. Traditional still-life subjects are still painted of course, and give most artists great inspiration and pleasure, but there are many other avenues that we can go down to find different and equally inspiring subjects.

Start by looking around your home, at ornaments for instance, a vase of flowers you have always liked, a brass plate on the wall perhaps brought back from a memorable holiday, a porcelain figure which reminds you of days gone by. These are subjects all around you, just waiting to be painted. If you go into your kitchen it has a feast of still-life subjects: crockery, bread boards, cheese boards, a butter dish, kitchen knives, bottles, drinking glasses – the list is almost endless. Now have a look in the garden shed, or the garage, and there you will have spades, forks, rakes, shears, brooms, plant pots, planting boxes, balls of string, gloves, old bottles, wellington boots, a wheelbarrow, and so on. A woodwork enthusiast may have chisels, saws, pieces of wood, nails, planes and hammers. You may have individual items that would make the centrepiece for a still life, such as an antique clock, or an old copper kettle. Something unusual or special can always give an ordinary still life a tremendous lift.

Another source of subjects is hobbies and pastimes. The range is almost inexhaustable. Take painting itself. Look at the interesting still-life groups that can be made from your painting equipment – so long as you are not using it! With fishing and all the equipment an angler has (I am one, so I know) you could paint still life for months without going any further than your tackle. Add to that the coloured floats, metallic reels, nets, baskets, hats, and you can create some very exciting paintings.

There are many possibilities, so let us look at which things go well together. In general there are no rules. If you want to paint a garden spade with a loaf of bread, go ahead. If you try to sell the painting you might have a little difficulty because it is unconventional, but if you have enjoyed painting it, then the privilege is yours.

Usually objects in a still-life group are related in some way, either by tradition, such as a vase placed with vegetables, or a pewter plate with grapes, or by subject, or even colour. A selection of vegetables is appropriate, or a group of kitchen items, or gardening tools. In capturing a particular colour range, you could choose predominantly green vegetables, or something copper arranged with red and orange fruit. In the end the decision is yours, you can be traditional, adventurous, or way out but, remember, always paint what inspires you.

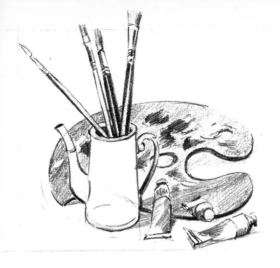

Fig. 14 IDEAS

HOBBIES
fishing
painting
woodwork
sewing
pottery
photography
horse-riding
cricket
tennis
golf
squash
snooker
darts

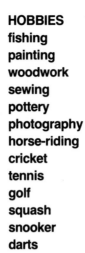

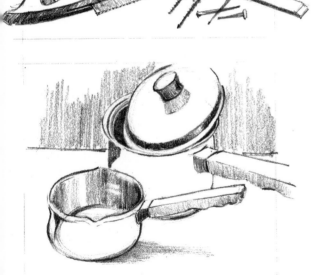

KITCHEN
saucepans
utensils
crockery
bottles
cutlery
glasses
food containers

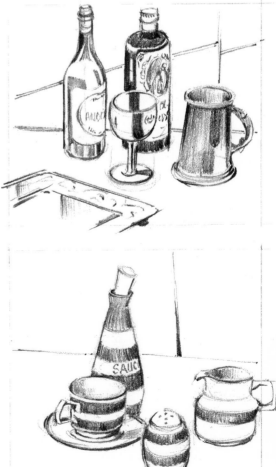

Fig. 15 MORE IDEAS

TRADITIONAL
bowls

baskets

vases

brass and copper
plates

lamps

ornaments

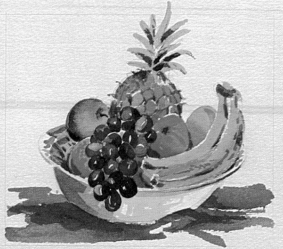

FRUIT
apples

grapes

bananas

pears

oranges

melon

pineapple

FOOD
bread

cheese

eggs

biscuits

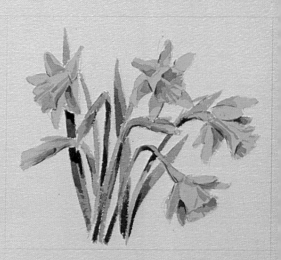

MUSICAL
INSTRUMENTS
banjo

guitar

trumpet

drums

recorder

FLOWERS
cut flowers

VEGETABLES
onions
marrow
peppers
potatoes
cabbage
tomatoes
lettuce
celery
carrots
cucumber

GARDENING
spade
fork
rake
watering can
shears
boots
plant pots
wheelbarrow
broom

GENERAL
after a meal
corner of a room
books
children's toys
dried flowers,
leaves and grasses

DRAWING YOUR SUBJECT
SIMPLE PERSPECTIVE

Most students want their work to seem three-dimensional rather than flat or too primitive-looking, so knowing a few basic rules of perspective is a good help to painting a realistic still life. However don't let it worry you too much, as a still-life subject, or any painting for that matter can be achieved without too much knowledge of perspective.

The key to drawing and painting still life, as with any other subject, is observation. Learn to observe, to know what you are looking for (this will come with experience), and learn a few basic rules of perspective. Soon you will be drawing some very commendable still lifes. Now let us look at some elementary rules.

When you look out to sea the horizon will always be at your eye level, whether you are on top of a cliff or lying flat on the sand. So we can call the horizon eye level (EL). As a still-life subject is normally contained in a room, you find your eye level by holding a pencil horizontally in front of your eyes at arm's length, and where the pencil hits the opposite wall is your eye level. If two parallel lines could be marked out on the ground and extended to the horizon, as you look into the distance they would appear to narrow gradually, until eventually they meet at what is called the vanishing point (VP). You may have noticed this when looking at railway lines, the two lines appear to get closer together and disappear in the distance – at the vanishing point.

For our still-life drawing there are two basic shapes that concern us: a cube and a cylinder. Look at **fig. 17** and you will see that I have drawn three boxes on a table. The first box (a) is a normal view of a table, the second view (b) is from the same level as the table, and the third (c) is from above.

In (a) I have drawn a line through the middle of the square and this represents the eye level (EL). At the left-hand side of the eye level I have made a mark, which is the vanishing point. With a ruler I drew a line from each of the corners of the square, and they all converged at the VP. This gave me the two sides, the bottom and the top of the box. To create the other end of the box, I drew a square parallel with the front of the box and kept it within the VP guidelines. The effect is that of a transparent box (in perspective).

In the drawings (b) and (c) the same box was used, drawing it exactly as in (a), but the eye level has been moved. In (b) the eye level is low, and in (c) the eye level is high. You can see from this exercise that the

eye level is very important. It is the first factor to locate when you start to draw. Once the eye level is fixed on your paper everything else will fall naturally into place.

Now look at (d) in which I have drawn a cylinder in perspective. First draw a cube and from the top surface draw two diagonal lines across each other. Where they meet is the centre of the cube. Now draw a line horizontally across the centre, and one from your VP down through the centre. This divides the top surface into quarters. Next draw the oval shape of the top of the cylinder (this is called an ellipse). Use the guidelines you have already drawn to help you. Now repeat exactly what you have done on the top surface at the bottom of the box, and draw two perpendicular lines to form the sides.

When you have done this look at the top ellipse and you will see that the half circle (ii) below the centre line is larger than the other half circle (i). This is always the case with an ellipse. Also the bottom ellipse (iii) is rounder than the top one, because it is furthest from eye level. If you look at (h), you will see what happens to a circle when it goes above and below EL. Try it by holding something round in front of your eyes, and move it up and down keeping it level.

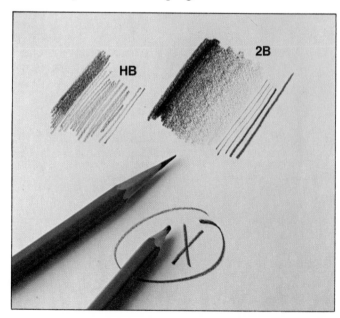

Fig. 16 The shading shows the different effects achieved with two grades of pencil: an HB and a 2B. Make sure your pencil is sharpened to a long point as the short one with a cross over it would be difficult to draw with

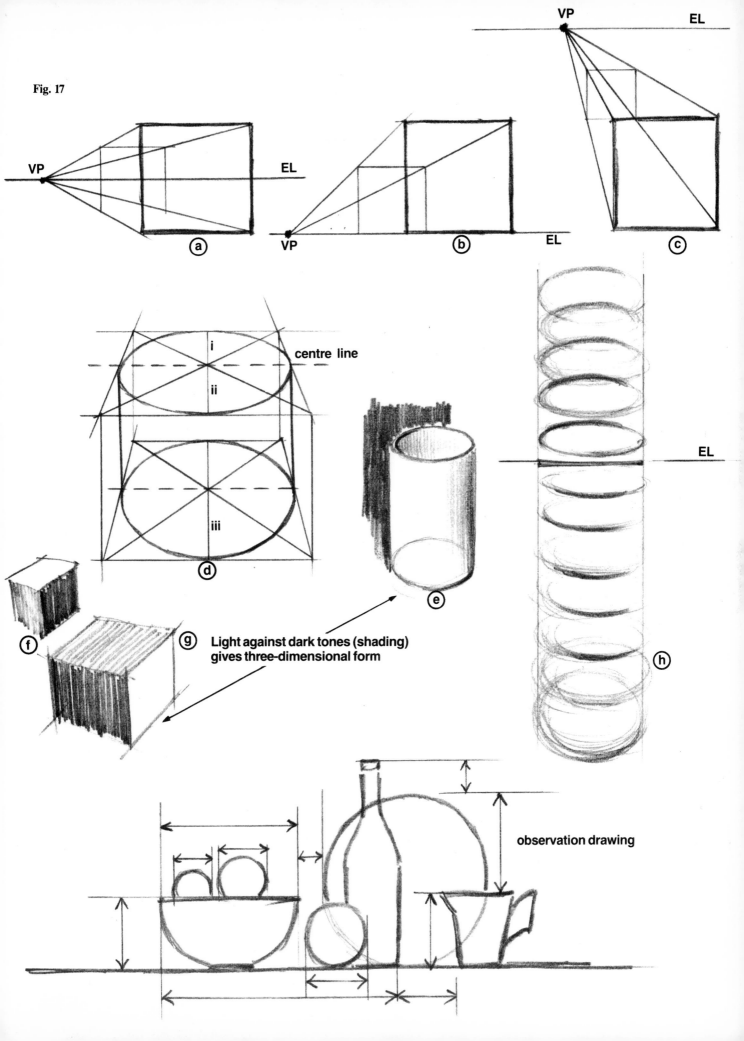

Fig. 17

VP

EL

ⓐ

VP

EL

ⓑ

VP

EL

ⓒ

i

ii

centre line

iii

ⓓ

ⓔ

ⓕ

ⓖ Light against dark tones (shading)
gives three-dimensional form

EL

ⓗ

observation drawing

I have shaded with pencil a cylinder (e) and a cube (g) to show how shading makes an object look solid and three-dimensional. Practise drawing perspective until you become familiar with it.

Look at the drawing in **fig. 17** which shows you how to observe a still-life group. I have drawn arrows to show the scale of the objects in relation to each other, and just as important, the amount of space in between them. For instance, the bottle sticks up above the plate by a height which is roughly equivalent to that of the left-hand orange in the bowl. When you are about to draw your group, look at it first and study the important points. Then start to draw, but all the time keep glancing at your subject, checking distances and the relative positions of the items, and compare them to your drawing. Your eyes and brain should never relax!

Before you start to use paint, it is a good exercise to *draw* simple still-lifes in pencil, and then shade in the tones. In **fig. 21** the drawings are reproduced in their actual size. You need a 2B or a 3B pencil, and perhaps an HB pencil for drawing fine lines. In **fig. 22** you will see two types of arrow. I have used these arrows in various places in the book to help you to understand the movement of the brush or pencil strokes. The solid black arrow shows the direction of the brush or pencil stroke, and the outline arrow shows the general direction the hand is moving in.

We have all used a pencil at sometime, so we should have an idea of how to use it. Unfortunately, most people have used it for writing, and old habits die hard. That way of holding a pencil is fine for controlled drawing and careful line work (see the 'short' drawing position, shown in **fig. 18**), but for more free and flowing movement – especially useful for the first 'planning in' of your drawing – you must hold your pencil at least 8 cm (3 in) from the point and at a flatter angle to the paper. This, the 'long' drawing position, gives much more versatility to the pencil strokes (see **fig. 19**). The 'flat' position is shown in **fig. 20**. The pencil is almost flat on the paper, held off the surface by your thumb and index finger. This allows you to touch and move over the surface using the long edge of the lead, which is ideal for producing large shaded areas.

Naturally, with the three different positions I have described there are infinite variations, but use these as a basis for learning to use a pencil again. Practise and doodle all the time until you really know your pencil. Look at **fig. 22** which has been reproduced here actual size. All the lines are drawn holding the pencil in the 'short' position. If you put your pencil onto the paper and draw a perpendicular line from top to bottom (a), you can only travel about an inch without moving your wrist or arm – practise this. Now keep your wrist stiff and move your arm – the lines can be drawn much longer (b). Do the same with fingers only drawing a curved line. Again you will be restricted, but you have

good control (c). Now keep your wrist and arm stiff, and the lines can be drawn much longer. The same principle applies to horizontal lines – you are restricted in length, but have more control, and if you keep your wrist stiff and move your arm you can draw long straight lines (d).

When you look at your subject, narrow your eyes until they are half closed, and you will see the dark and light areas, while mid tones disappear. By doing this you can distinguish the form of your subject better, and you will also see which actually are the darkest and lightest areas of your group.

It may be necessary to read this over a few times until you understand it, then practise as much as you can. Don't forget to observe, and above all, enjoy it!

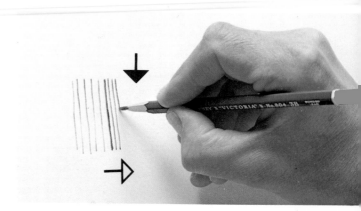

Fig. 18 'short' drawing position

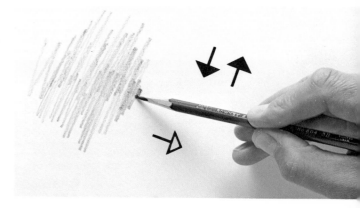

Fig. 19 'long' drawing position

Fig. 20 'flat' drawing position

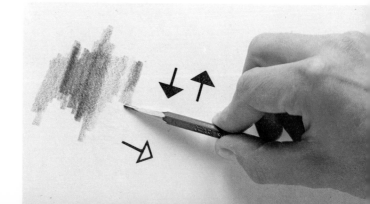

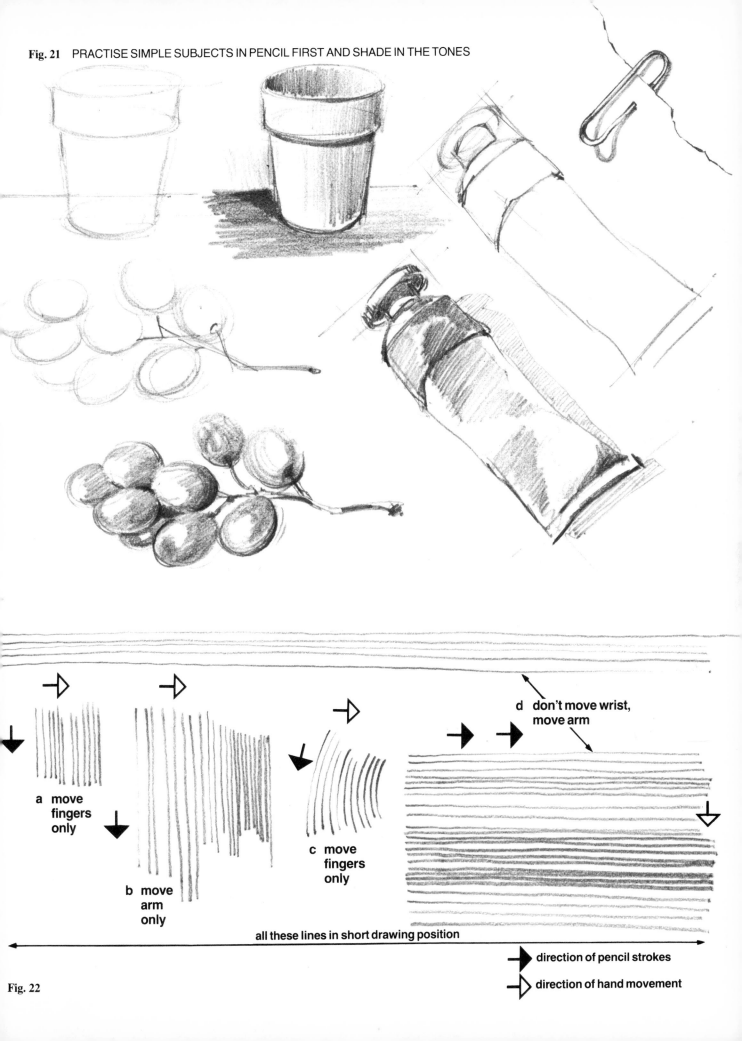

Fig. 21 PRACTISE SIMPLE SUBJECTS IN PENCIL FIRST AND SHADE IN THE TONES

a move fingers only

b move arm only

c move fingers only

d don't move wrist, move arm

all these lines in short drawing position

→ direction of pencil strokes

⇨ direction of hand movement

Fig. 22

LET'S START PAINTING
PLAYING WITH COLOUR

Now let us consider colour. Wherever you are, whether at home or outside, if you look around you there is colour everywhere. If you look at a garden full of flowers there would be hundreds of different colours and shades. This can be daunting to a beginner, so let me reassure you that you don't need hundreds of colours to work from. In fact, all colours can be made up from just the three basic primary colours: red, yellow and blue. (Primary colours cannot be mixed from other colours.) In **fig. 24** I have added a set of variations of the same colours to give greater scope to our mixing.

Whichever medium you decide to work with, watercolour, oil, pastel or acrylic, there are still only three primary colours, even though each colour can vary greatly in their range of tone. For instance, Cadmium Yellow, Cadmium Yellow Pale, Yellow Ochre and Lemon Yellow are all yellows, but they can look quite different when compared with each other. In this sense you still have a choice of colours even though you are restricted to primaries. In the next chapter we paint simple objects using only three colours and white. I have suggested which three colours to use. If you are a beginner use the colours that I have worked with throughout the book. It will make it easier for you to copy the exercises, and also will give you a feeling for colour. If you want to add to or leave out any of my choice of colours when you start to find your feet, then don't hesitate, each of us must find what suits us individually. This applies also to brushes and any other personal equipment that you use.

If you have decided which medium to paint in, then start experimenting with it. It is a very personal choice and depends a lot on the nature and character of the artist, but if you are not sure what to start with, then I would suggest watercolour for two reasons. First of all, even if we were not artistic at school, most of us were taught to use water-based paints. Usually these would have been poster paint in jars, or powder paint in tins, both of which need mixing with water. The brushes would have been cleaned in water and the ground or surface would have been paper. Therefore, there is a good chance that anyone who starts to paint using watercolours will not feel alien to the materials and as a result would be more confident.

Secondly, it is a very convenient medium to practise with. You can use the corner of a table and work away happily with very little equipment - a box of paints, brushes, a water jar and your paper - and there is no smell of turps or oil, as you would have with oil painting. Having said that, the choice is yours, but if you are uncertain when you buy your materials only get just enough to *start with* in case you change your mind and go on to another medium.

Whatever medium you have chosen, you must get to know it first. Use any scrap paper - brown wrapping paper, the back of leftover bits of wallpaper, sheets of cheap white paper, even newspaper - just play with the paint. Don't worry about trying to mix special colours, let your brush push the paint around making shapes, in fact, what I call determined doodling (look at my doodles in **fig. 23**).

Even if you only get a feel for the paint by playing with it, you will gain confidence as you practise. The more confident you are, the quicker you learn, and soon you will be painting masterpieces! Remember, *with every brush stroke, you are gaining experience.*

Now let us try mixing colours. You will see from **fig. 25** that I have mixed yellow and blue to make green, and a yellow and red to make orange. Mixing the three primaries together will make black. I don't use readymade black (except with pastels), because I find it a dead colour, but some artists do use it, so if you want to, go ahead, but be careful. When you are mixing a colour always put the *main colour of the mix* into your palette first. For instance, if you want to mix a yellowy green, then put yellow first and afterwards mix a blue into it, gradually mixing in the amount you need to make your colour. If you put the blue in first, the emphasis would be on the blue, and you would have to add a lot of yellow to make your green yellowy. You might get the right colour eventually, but you would have far too much paint mixed.

Look around at the objects in your room and try to copy the colours. Remember that a colour can change slightly when it is placed against another colour, so if you paint on white paper and you are painting, let us say, a cushion on a chair, it might not look quite right because it is against a white background. However, if you paint in the colour of the chair close to the colour of your cushion, then you will find the colour looks more realistic. Keep practising and you will find, like the other things you have learned so far, that you will improve and you will be able to mix your colours well enough to paint a good still life.

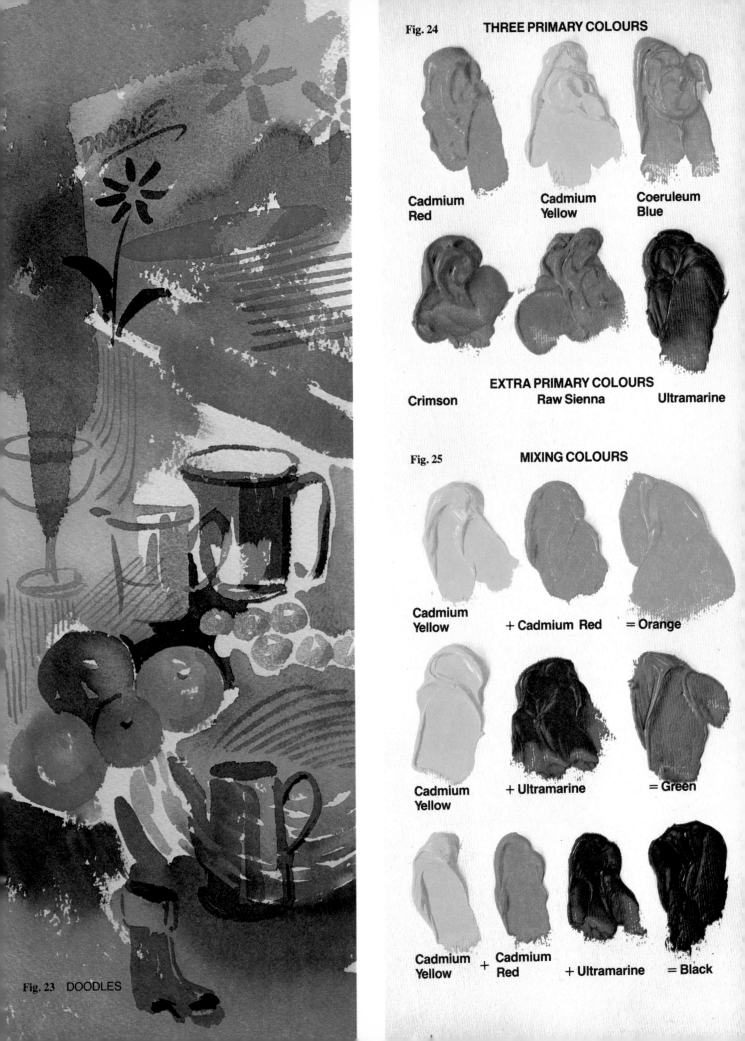

Fig. 23 DOODLES

Fig. 24 THREE PRIMARY COLOURS

Cadmium Red

Cadmium Yellow

Coeruleum Blue

EXTRA PRIMARY COLOURS

Crimson

Raw Sienna

Ultramarine

Fig. 25 MIXING COLOURS

Cadmium Yellow + Cadmium Red = Orange

Cadmium Yellow + Ultramarine = Green

Cadmium Yellow + Cadmium Red + Ultramarine = Black

SIMPLE EXERCISES
SINGLE OBJECTS
USING ONLY THREE COLOURS

I have designed these exercises to combine everything you have learned so far. You have now attempted simple perspective, using a pencil, drawing simple subjects, practising with your medium, learning how it reacts and how to mix colours. All of this sounds very impressive and if you have learned these skills to a competent standard at this stage of the book, then you have done very well. As you practise, you will find that some aspects come naturally, and you are likely to be proficient at these, and not so good at others. Everyone has certain natural talents, but you will have to practise the things that you are not so good at more often. Even advanced students need to do this – and so do I!

When you first do these exercises, don't worry if you think a certain part of a painting has gone wrong. Keep it simple, after all, you can do it again knowing what not to do next time. I have done each one in stages. These are simulated, but the main exercises at the end of the book have been photographed at each stage of their development, so you can see how the same painting progresses until it is finished. Copying these exercises will give you confidence for when you begin to paint from your own life subject. Look at each stage before you start and analyse it. In other words, *observe* your subject.

Then when you know what to do start your painting. The colours I have used are shown next to each exercise. I have worked with four mediums, but if you want to paint, say, the oil exercises in watercolour then have a go, you might find it a little difficult, but it is good practice. Do remember that it is important in all these exercises to start mixing your colours with the same one that I start with (this is the main or predominant colour). With the three primary colours (red, yellow and blue), I have used white with the oils and acrylics. However, with the pastel exercise the three primary colours were not used as they would have been difficult to mix, so I used three other colours instead, together with black. This is quite common practice in pastel painting. The actual size of each of the seven exercises is one quarter larger than they have been reproduced on the page.

Watercolour Your first exercise (**fig. 26**) was painted on Whatman 400 gsm, Not surface watercolour paper. The reason I chose the pear first is because the shape of a pear cut in half is never the same twice. Therefore, if your drawing is not exactly the same as mine, it can still look like a pear. It will be good for your morale if your first attempt at a subject is successful, and this will give you confidence. Another important thing to remember is that when you are copying my exercises, don't try to follow them line for line, or you will become tense and inhibited. If your brush goes a slightly different way, then let it happen, it is you painting the picture – not me! Your painting will flow more easily and, more important, your own character will show through.

I used a no. 10 and a no. 6 sable brush for this exercise. First draw in the pear with an HB pencil, then paint in the background. When this is dry paint the skin round the edge and the surface of the pear. At the third stage paint the cut surface while the skin is still damp at the edges. Before the cut surface of the pear dries put in the core. You will find that this runs into the wet paint which is exactly what we want. The blending of the colours gives a softer more natural effect. Now add the shadow underneath the pear. Finally use a little more dark paint to give the core detail, and while it is still wet put in the stalk and the blemishes on the skin.

Watercolour The second exercise (**fig. 27**) is worked on the same paper as the previous one. Again, the shape of an onion allows some artistic licence so you can concentrate on painting. If you look at the four stages, you will see that the painting is built up of washes of colour, which help to give the layered effect of onion skins. Each colour is washed over when the previous wash has dried. This helps to keep the crisp and translucent look of the onion. I used a no. 10 sable brush for the main part, and a no. 6 sable for the detail work which I did towards the end (stage four). When you are putting detail in watercolour use a small brush, and don't overload it with water, keep it just damp rather than very wet. This will help you to draw thin lines, and it will stop the paint spreading when you don't want it to.

Acrylic In the next exercise (**fig. 28**) I used Cryla Flow Formula acrylics, and I worked on brown wrapping paper to show you how you can practise with cheap grounds. The brushes I used were a no. 4 flat nylon brush for most of the work and a no. 6 sable for the detail. I pinned the paper down on to a board and drew the plant pot with a 2B pencil. With this exercise you

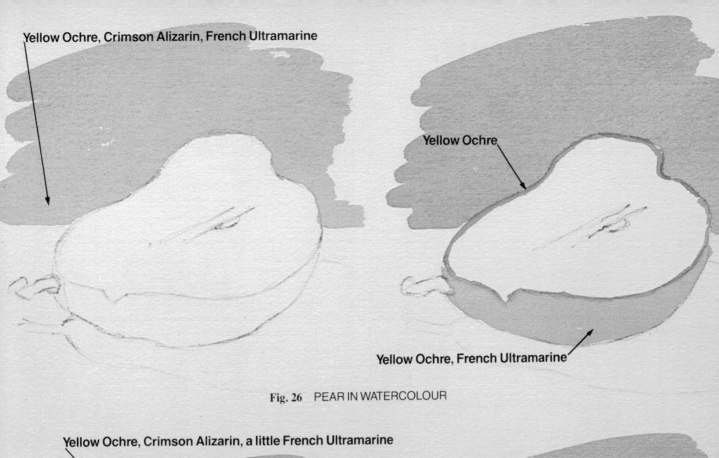

Yellow Ochre, Crimson Alizarin, French Ultramarine

Yellow Ochre

Yellow Ochre, French Ultramarine

Fig. 26 PEAR IN WATERCOLOUR

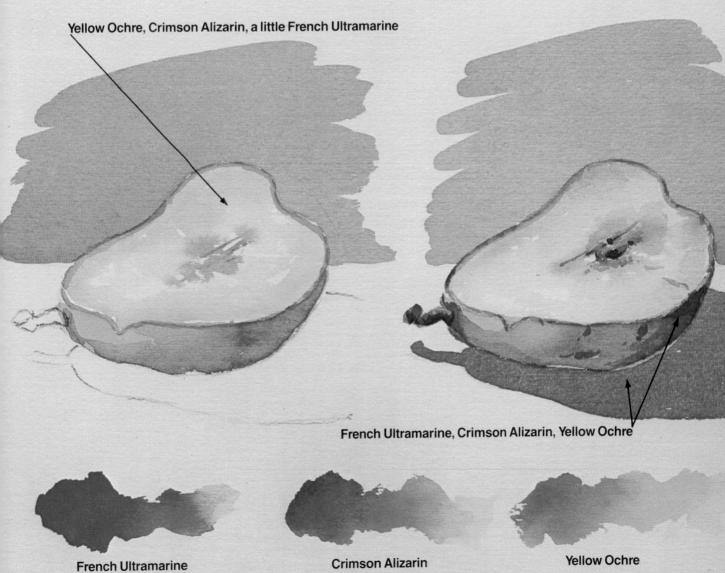

Yellow Ochre, Crimson Alizarin, a little French Ultramarine

French Ultramarine, Crimson Alizarin, Yellow Ochre

French Ultramarine

Crimson Alizarin

Yellow Ochre

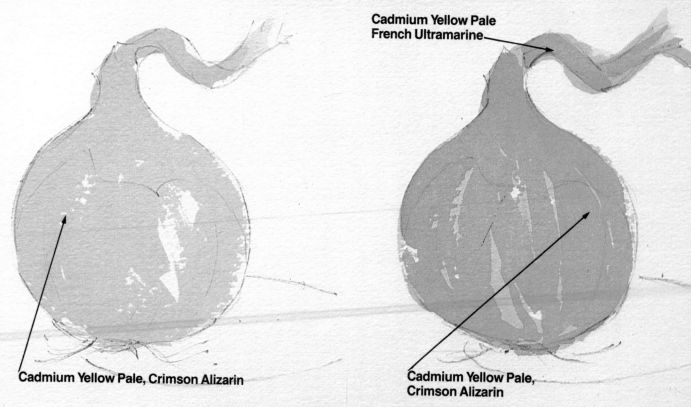

Cadmium Yellow Pale
French Ultramarine

Cadmium Yellow Pale, Crimson Alizarin

Cadmium Yellow Pale,
Crimson Alizarin

Fig. 27 ONION IN WATERCOLOUR

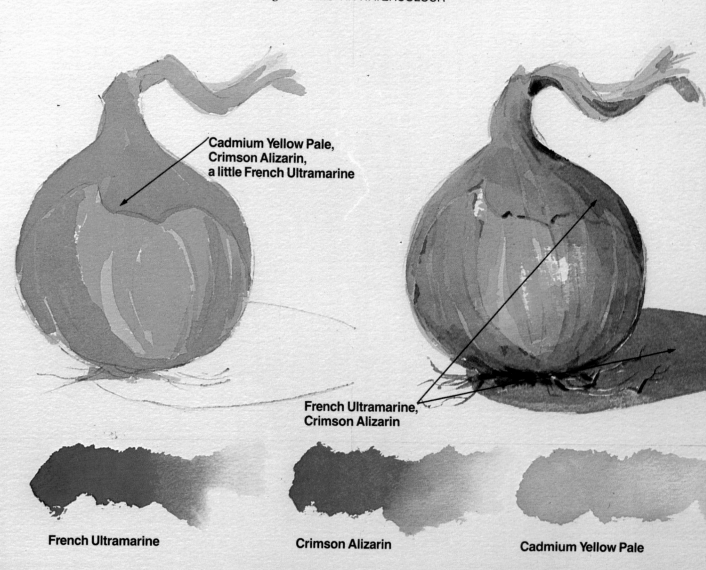

Cadmium Yellow Pale,
Crimson Alizarin,
a little French Ultramarine

French Ultramarine,
Crimson Alizarin

French Ultramarine

Crimson Alizarin

Cadmium Yellow Pale

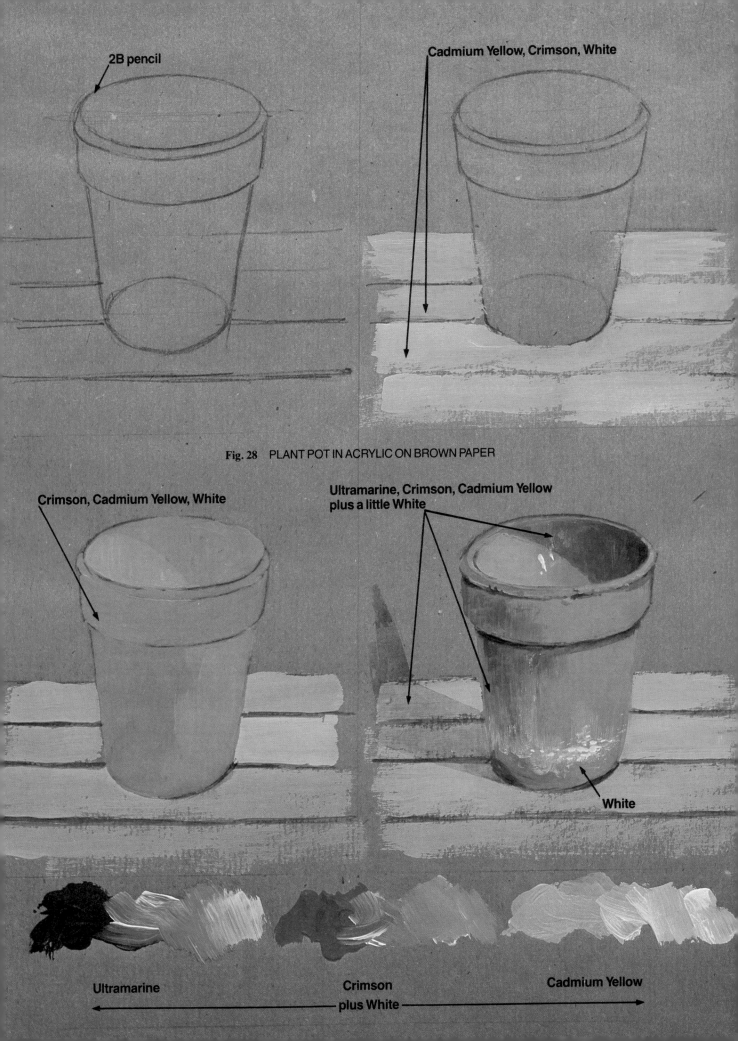

2B pencil

Cadmium Yellow, Crimson, White

Fig. 28 PLANT POT IN ACRYLIC ON BROWN PAPER

Crimson, Cadmium Yellow, White

Ultramarine, Crimson, Cadmium Yellow
plus a little White

White

Ultramarine

Crimson
plus White

Cadmium Yellow

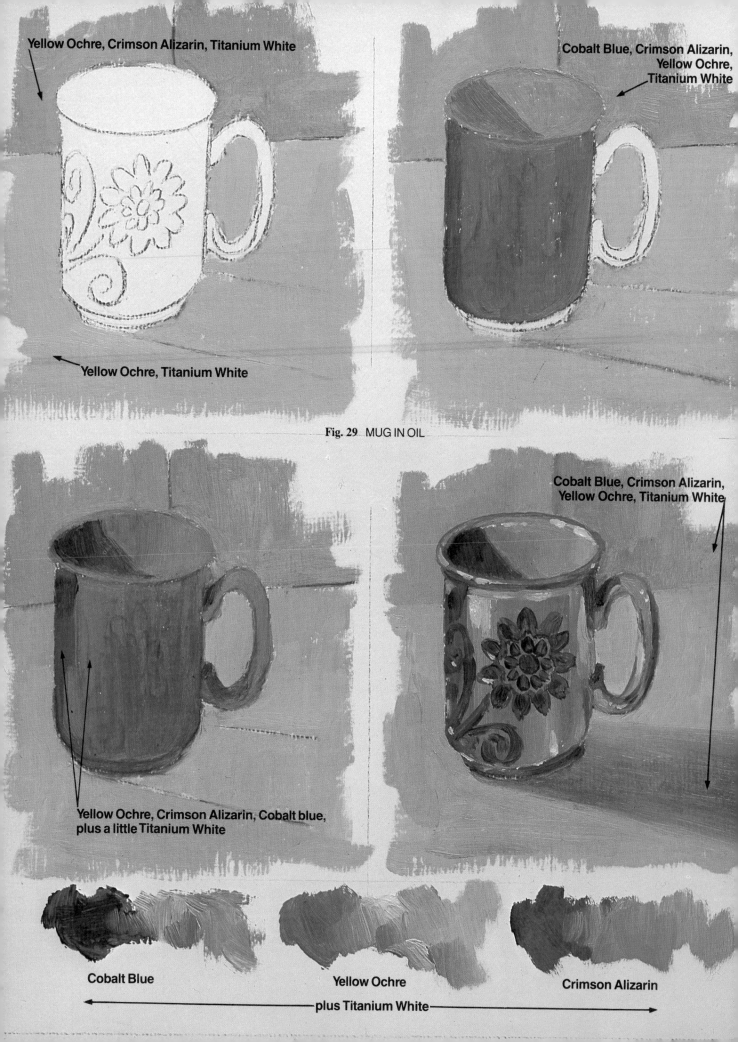

Yellow Ochre, Crimson Alizarin, Titanium White

Cobalt Blue, Crimson Alizarin,
Yellow Ochre,
Titanium White

Yellow Ochre, Titanium White

Fig. 29 MUG IN OIL

Cobalt Blue, Crimson Alizarin,
Yellow Ochre, Titanium White

Yellow Ochre, Crimson Alizarin, Cobalt blue,
plus a little Titanium White

Cobalt Blue

Yellow Ochre

Crimson Alizarin

◀——————————— **plus Titanium White** ———————————▶

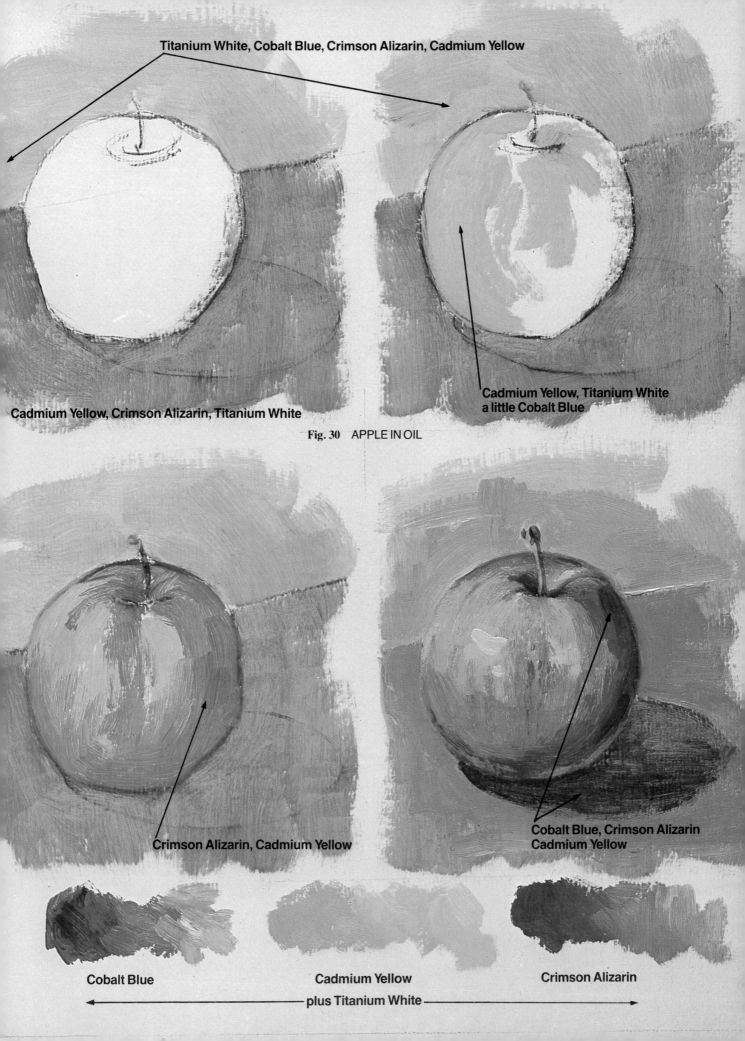

Titanium White, Cobalt Blue, Crimson Alizarin, Cadmium Yellow

Cadmium Yellow, Crimson Alizarin, Titanium White

Cadmium Yellow, Titanium White
a little Cobalt Blue

Fig. 30 APPLE IN OIL

Crimson Alizarin, Cadmium Yellow

Cobalt Blue, Crimson Alizarin
Cadmium Yellow

Cobalt Blue Cadmium Yellow Crimson Alizarin

← plus Titanium White →

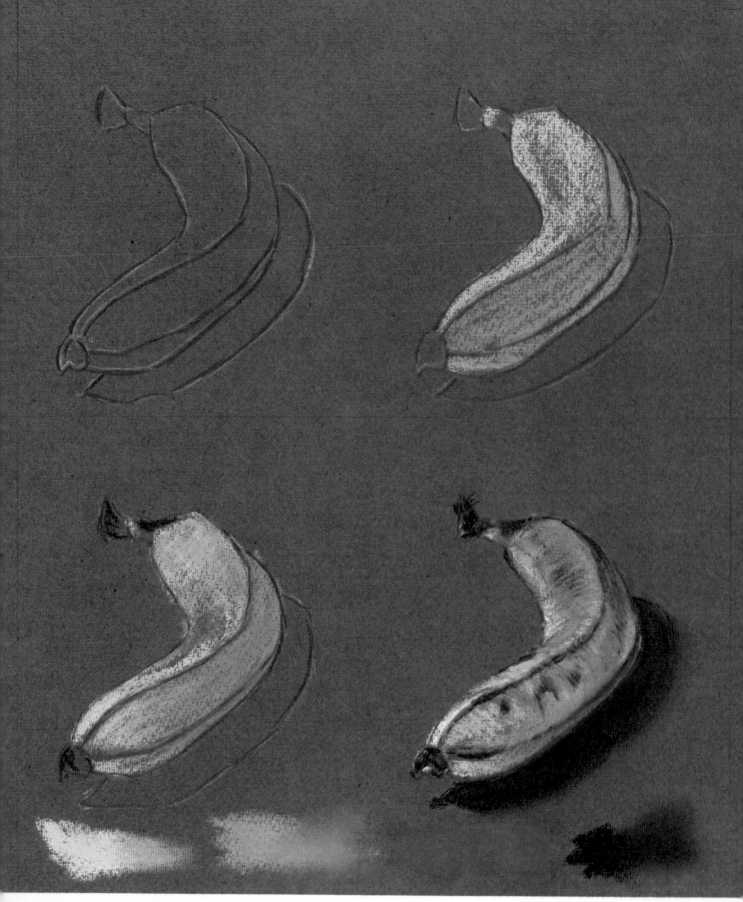

Cadmium Yellow tint 4 Yellow Ochre tint 6 Burnt Umber tint 6 Ivory Black

Fig. 31 Banana in pastel
In stage one draw with a 3B pencil and Cadmium Yellow tint 4. Use Cadmium Yellow tint 4 and Yellow Ochre tint 6 at the second stage. In stage three add Burnt Umber tint 6, and in stage 4 Ivory Black

have to be a little more careful with your drawing as there is less room for error. Spend time on the drawing until you feel it looks about right, then start to paint. In the final stage where I put the shadow in with a wash, I watered the paint down like watercolour and painted over the existing paint. The under-paint shows through giving a good shadow effect.

Oil This exercise (**fig. 29**) is also one for which you need to spend more time on the drawing. If you painted the last one in acrylics then try this one in the same medium, also on brown paper. I did it in oils on oil painting paper – a good ground to practise on as it is cheaper than canvas. In addition to the three primary colours I used a gel medium, which is mixed with the colours to speed up drying. How much you use is entirely up to you. Experience will enable you to decide how quickly you want the paint to dry. To start with try mixing equal amounts of gel medium and colour.

I drew the mug in first with an HB pencil, then I put paint thinly on the background. This allows the pencil lines to show through, although I didn't bother to keep the design on the mug showing as well. I painted that over at the end. In the last stage I also used thicker paint and worked over the background again covering up the pencil lines as I did so. Notice how the shadow is lighter at its furthest edge by the mug. I used a no. 6 and a no. 4 bristle brush, and a no. 6 sable for a little detail work.

Oil I did this exercise (**fig. 30**) using the same equipment and the same paper as for the last one. When you paint the apple, let your brush strokes travel in the direction of the shape of the apple – this will help to show its form.

Pastel The sixth (**fig. 31**) was painted on Ingres paper. I did the drawing with a 2B pencil, and then again with a thin pastel line to make sure it could be seen when reproduced for the book – normally pencil would do. In the third stage rub the colours together with your finger, then work in the blemishes on the banana skin and finish the shadows and highlights. Wherever you feel like rubbing the pastel in with your finger, go ahead.

Acrylic The last exercise in this series (**fig. 32**) was painted using the same equipment as for the plant pot exercise except this one is painted on newspaper. It is a very economical way to practise, and it is pleasant to work on. I used a 3B pencil for the drawing, but not too sharp or it could tear the paper!

Work your way through these exercises at your own speed and if you want to try different techniques to mine, do. It is all experience and remember, *your* personality must come through in the end. Good luck.

Fig. 32 Mushrooms in acrylic
Use White, Cadmium Yellow, Crimson and Ultramarine in stage one. For the dark areas in stage two paint a mix of Ultramarine and Crimson with a little Cadmium Yellow and White. In stage three add Ultramarine for the shadows and more White for the highlights

Ultramarine Crimson Cadmium Yellow +White

DESIGN AND COMPOSITION
SETTING UP YOUR SUBJECT

We all see things differently and we all like different things to some degree. If your family had to choose a wallpaper for a living room, the chances are that not everyone would go for the same paper. Either the design of the paper does not appeal to everyone, alternatively, even if they all liked it, the finished room would not necessarily appeal to everyone from the point of view of good decor or design. Similarly, in the choice of items for still life, you could like an object, such as a vase on its own, but not when it is part of a group. The group may not be well designed as a whole, simply because of the vase. The objects themselves play just as important a role individually as they do in the overall design of a group. If you have something that you really like and you want to use it in a still life, then find other articles to go with it.

Design is a specialized subject and needs a great deal of study in its own right. We all have natural talent for certain aspects of painting and, of course, some people find design is theirs. However, if we follow some basic rules, as in most areas of painting, practice and patience will bring results to everyone.

I have entitled this section *Design and Composition* because, in painting, they mean the same thing to me, namely: *the positioning of objects on paper in a happy way that enables you to tell a story visually to the onlooker.*

Since the still-life group will finish up on a piece of paper or canvas, then the whole group has to be seen with an edge around it and it must be designed within those boundaries. Here we can learn some simple rules relating to a design on paper. Let us start with a very old system I was taught at art school, which is now second nature to me. Although it is a good rule of thumb, don't be stereotyped by sticking rigidly to rules. A deviation from the expected to a more personal approach can make an original and sometimes unusual picture.

Look at **fig. 33**. I have divided the paper, vertically and horizontally, into thirds. Where they cross at a, b, c and d I have called focal points. If your centre of interest is positioned on or around a focal point, then you should have a good design. Look at the orange at focal point b. It looks happy (by which I mean that it works well on the paper). Now look at the one below it. The orange is in the centre of the painting and, as such, is uninteresting and characterless because it is placed too symmetrically.

The next stage is achieved by adding colour. This may be stronger, lighter, darker, or even an odd or unexpected colour that enhances the focal point, which may be an object or even a space between two objects. Remember, space is just as important in a still-life group as the objects themselves. An ugly space made by two objects close to each other, can spoil the design of a group. Equally, a pleasant shape created by the space around it can make all the difference. Avoid two objects only just meeting. In a group, when two things are close together, either let them overlap, or make a definite miss and put plenty of space between them. In design I was always taught that one should either 'miss' or 'hit' a subject (see **fig. 33**). It is a good rule to remember.

Since you can set up your own still-life group, then the design of that group is much more flexible than, say, a landscape. For instance, you can make up a group of just green items, because you may be in your 'green' period. Or you can decide that you want to paint hard-edged items, such as drinking glasses, bottles, and so on. Therefore, you are not only designing a picture on paper, you are also designing the 'landscape'. However it is important, because you have so much scope, not to spend most of your time worrying about what to paint, or you will not be doing very much painting! Find half a dozen items that you like and keep re-designing them into different groups and paint from them each time. You will become so familiar with these things that you will learn to paint them better simply because you know them well from different viewpoints.

In **fig. 33**, you will see examples of the use of focal points. Having said all this about design, the traditional rules in painting, as in many other aspects of the arts, are gradually being relaxed. After all, twenty years ago an actor would never have turned his back to the audience or the camera, yet now this is commonplace and we accept it, as we do with many new ideas or relaxation of rules. So, if your quest for design sends you off into all sorts of weird and wonderful directions, don't stop yourself. You will be expressing your feelings and, if you are enjoying it, then carry on.

If at the end of the day, your masterpiece is not accepted by your friends, at least you have enjoyed yourself through your experiments and most probably have learned something from them. You may even start a new trend in still-life painting!

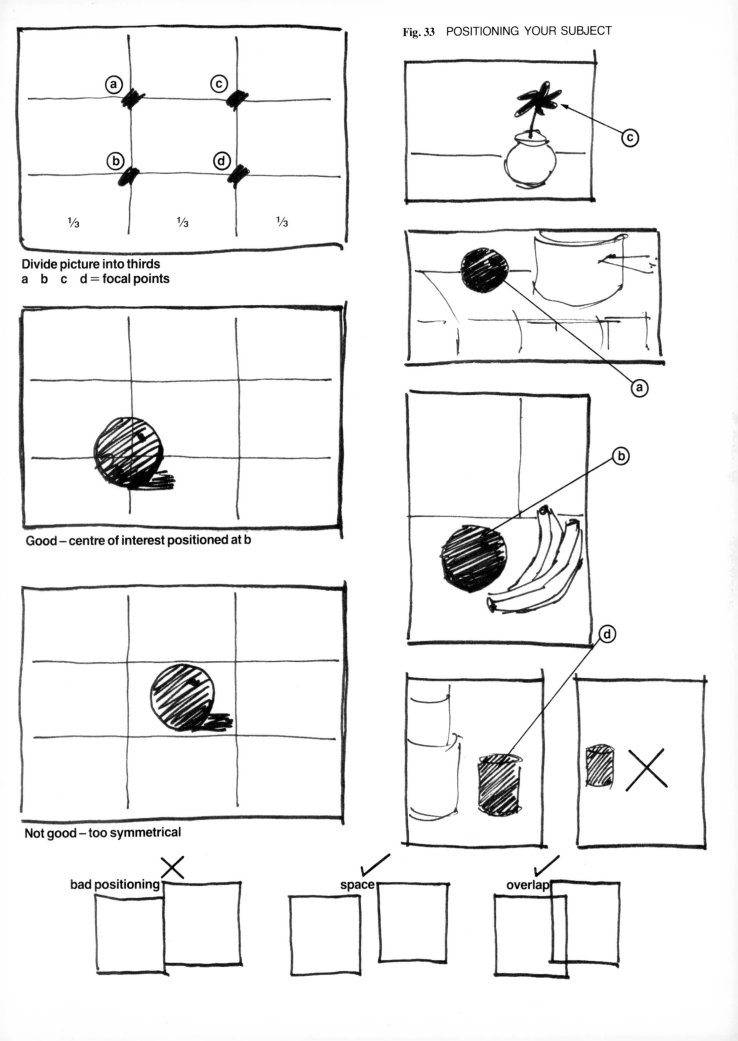

Fig. 33 POSITIONING YOUR SUBJECT

Divide picture into thirds
a b c d = focal points

Good – centre of interest positioned at b

Not good – too symmetrical

bad positioning ✗

space ✓

overlap ✓

Setting up your subject

The setting up of your still-life subject, as I said earlier, is really part of your design ability. Naturally, there are other physical aspects to be considered, so I will take you through the various stages. First of all let us deal with a total-control still life. You are sitting in a room ready to go, with nothing to paint.

If you remember what I said earlier, you must be inspired by what you are going to paint. The first stage then is to look about the house to see if anything inspires you sufficiently to paint it. At this stage of the book, you have probably selected quite a few objects and you may even have practised painting them already. The next stage is very important. Make sure that where you are going to set up the still life is not in anyone's way and, of course, that no one will want to use any of your articles!

When you set up a still life, please warn the rest of the family where it is, and *exactly* what it is. When you have decided where it is going to be you must arrange it on a very firm base. A delicate tray on a flimsy little table could be disastrous. It could easily be knocked over, even if you are being careful. If you decide to set it up on a table which has to be used before you have finished your painting, then put the group on a board, and then, if it becomes necessary you can remove the entire board with the group still in position, and replace it later. Naturally, this depends on the size of your group. If you are using a cloth base, it could be useful to pin or stick the material down in case you accidentally move it. This could not only move the material but also the objects on top. I suppose all this information is, simply, common sense, but it is better to be safe than sorry.

The next stage is to arrange the items into a good still-life group. First, start with your centrepiece. This is the piece that you want your design to centre on. Then place your other objects around it. You will, quite naturally, set it up with the position that you are going to paint from in mind, but remember that it is three-dimensional and if you change your drawing position, even slightly, the still-life group could make a very different picture. This is another reason why it helps to have your group on a board. You can gently move it round to gain different viewpoints. The background can be a piece of material, a towel, a coat, a sheet of coloured board, or simply the wall behind. A chair - especially a kitchen chair, for instance, which has plenty of character - is good for setting up a group. The back of the chair is a ready-made background, and it is reasonably easy to move round when you are setting up and looking for different angles.

To start with, as always, keep your groups simple. If you set up flowers, fruit, vegetables or any food that can deteriorate, be prepared to replace items that go off. Don't worry too much if you have to put a different piece of bread, or a new tomato, or whatever into your still life, you should be able to work from the new objects without spoiling your painting.

Now we come to the most important aspect - the light source. The best way of all is simply to use an angle-poise lamp and put it near your group, moving it around until the effect on the group satisfies you. Initially, it is easier to have areas of strong light and shade. The sharp contrast will enable you to see the form of your objects better. Naturally, the lighting is, in effect, a design element, which can enhance your group. So, as you progress, experiment with light to see the different effects you can make to create exciting still-life groups. Let me warn you again that the more time you spend on building the group the less time you have for painting. On the other hand, you might find that you enjoy it so much that you turn into a 'still-life builder'. I've never heard of one - but you could be the first!

To help you decide whether the group you have built will look right on paper, cut out a mask from cartridge paper measuring approximately 15 × 10 cm (6 × 4 in). Return to your drawing position, hold the mask up (**fig. 34**), and look through the aperture at the group. Move it around until you find a good view. When you have, that is what you should paint. In the drawings in **fig. 36**, I have used only one still-life group, but sketched it from various viewpoints to make different pictures within the pencil outline. I have also drawn a red outline over the pictures to show how differently designed paintings can be achieved. From one still-life group it is possible to do 12 different paintings, i.e. there are 12 different viewpoints from which to choose the one that inspires you the most.

For semi- and minimal-control still life, the rules are the same. Of course, you have less control, consequently, it is even more important to let the family know what you are choosing, because you could find your subject disappears. If you were painting a group by a window, which included a bowl of fruit, you could easily lose an apple or a banana! Equally, a cup and saucer included in a group in the kitchen could disappear. Find your light source and remember that if it is natural, it will change as the day goes on. If it is possible try to use artificial lighting so that you have more control.

The one thing you don't have to do with this type of still life is to set it up. However, after choosing your drawing position, don't be afraid to move some part of the subject if it will help the design, but do this when you have more experience.

Finally, don't forget the obvious. A still life can even be painted from just one object against a plain background and be extremely effective. Simple ideas are often as successful as intricate ones, so don't look too hard.

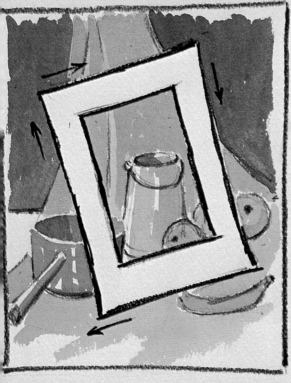

Fig. 34　LOOK AT SUBJECT THROUGH A MASK

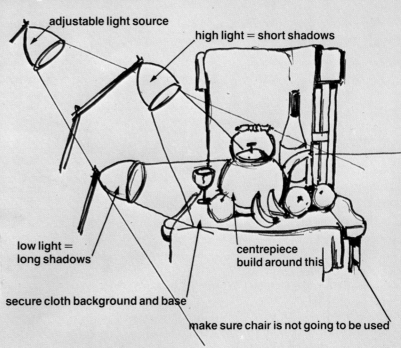

adjustable light source

high light = short shadows

low light =
long shadows

centrepiece
build around this

secure cloth background and base

make sure chair is not going to be used

Fig. 35　CONTROLLING THE LIGHT

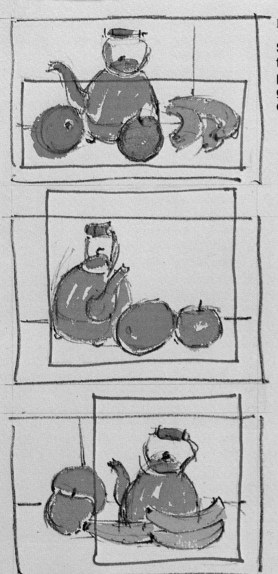

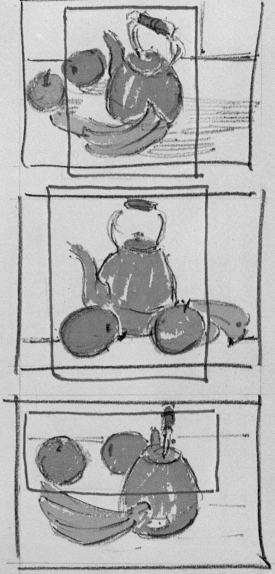

Fig. 36

**Same still-life group seen
from different view
points and using parts of
group for different
designs**

SIMPLE EXERCISES
MORE THAN ONE OBJECT USING UP TO SIX COLOURS

These exercises, on the following three pages, will make use of the skills that you have acquired so far. After doing the exercises using only three colours, some of you will find it easier to use another three, so off you go. There is no short cut to this type of subject, and this must be remembered when you are setting up your own still life. Before you embark on painting it, look at it objectively and decide whether you can paint all the things you have put into it. If you are *at all* worried then take away the items that are concerning you and rearrange your subject. Time and experience will produce the skill you require for difficult subjects.

All these exercises were painted twice the size that they have been reproduced here. When you copy my still lifes which are in two dimensions, it will help you when you set up your own subjects and work from life (in three-dimensions). Don't worry if, for instance, you are painting apples or oranges all the time. After all, a landscape artist paints trees time and time again, and look how many times a marine artist paints a boat! The point is that there are certain objects that are a still-life artist's 'bread and butter': fruit, vegetables, vases, ornaments, and so on.

The first exercise (**fig. 37**) I painted in oil colour and worked on a canvas panel. I also used gel medium to quicken the drying of the paint. The brushes were a no. 4 bristle and a no. 6 sable. For oil painting, a nylon round brush can always be used in place of a sable if desired. The colours I used were Cadmium Yellow, Cobalt Blue, Crimson Alizarin, Viridian, Cadmium Red and Titanium White.

First draw in the picture with an HB pencil. Then go over that with a very thin wash of Cadmium Yellow and Crimson Alizarin, mixed with gel medium and turpentine. Draw over your pencil lines with your no. 6 sable brush. This will dry quickly, and you can work over it. The reason for this, is that if you had left the pencil as it was, because there is quite a lot of drawing in the picture, you would have smudged it sooner or later, and it would end up looking dirty and messy. A quicker way of doing this is to draw it in with a thin wash of acrylic paint and this will dry almost immediately. If you paint in oils it is a good idea to have one tube of acrylic, say Yellow Ochre, to use for drawing prior to painting in oil.

Next paint in the leaves of the plant, the plant pot and the vase holding the pot. Then put in the background, the table and shadows, using the same colours

in different mixes: Cadmium Yellow, Crimson Alizarin, Cobalt Blue and Titanium White. In the final stage paint in the watering can using Cadmium Yellow and Titanium White, then add Crimson Alizarin and Cobalt Blue to a little of the watering-can colour for the shadow areas. Paint dark and light areas on the leaves to give them depth. Put in the soil, red berries and any detail you feel it needs.

Fig. 38 is a much simpler exercise. It is also painted in oil and on the same ground. The same brushes were used as in the first exercise and the colours were Yellow Ochre, Cadmium Yellow, Viridian, Cobalt Blue, Crimson Alizarin, Cadmium Red and Titanium White. First, draw the picture in with an HB pencil. As there is not a lot of intricate drawing needed, I worked over the pencil without bothering to paint in the drawing, as I did in the first exercise. Then paint in the fruit using your no. 4 bristle brush.

I would like to make a general note here before you paint in the background. Since I have done so many still-life subjects in a short space of time while working on this book, I have found that with some subjects, I have painted in the objects first. You probably wonder which should be done first – the subject or its background. Is there a general rule for this? I don't believe there is. First and most important, I can see no reason why *you* can't decide which you paint first. In fact, the more I have thought about it, the more I believe it comes down to the subject matter and your assessment of it as a painting, and how you want to go about painting it. The medium can dictate to a certain degree which is painted first, but *you* must decide which way you feel you could work better. Always remember that a painting is a 'whole', and as something must go onto the board first, it might just as well be what you feel happiest doing.

Now paint in the background and add detail to the fruit. Look at the green apple in the middle and you will see a highlight on the lower edge in the shadow area. This is known as a reflected light. It is always seen on round objects to some degree. Half-close your eyes and look at some fruit to see if you can spot it. Reflected light always helps to make the object appear more round.

For the third exercise (**fig. 39**) I decided to paint a glass. Look what shapes there are behind it. Leave the paper white to highlight areas which suggest the shape of the glass, then paint the shapes that show through.

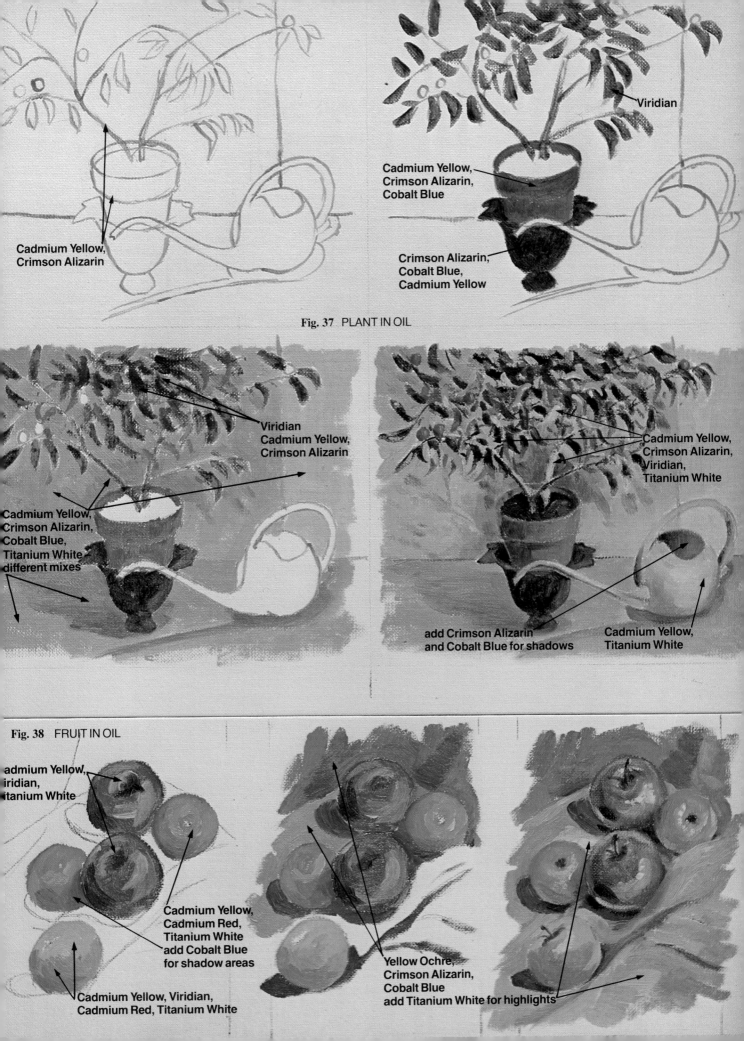

Cadmium Yellow,
Crimson Alizarin

Viridian

Cadmium Yellow,
Crimson Alizarin,
Cobalt Blue

Crimson Alizarin,
Cobalt Blue,
Cadmium Yellow

Fig. 37 PLANT IN OIL

Viridian
Cadmium Yellow,
Crimson Alizarin

Cadmium Yellow,
Crimson Alizarin,
Cobalt Blue,
Titanium White
different mixes

Cadmium Yellow,
Crimson Alizarin,
Viridian,
Titanium White

add Crimson Alizarin
and Cobalt Blue for shadows

Cadmium Yellow,
Titanium White

Fig. 38 FRUIT IN OIL

admium Yellow,
iridian,
itanium White

Cadmium Yellow,
Cadmium Red,
Titanium White
add Cobalt Blue
for shadow areas

Cadmium Yellow, Viridian,
Cadmium Red, Titanium White

Yellow Ochre,
Crimson Alizarin,
Cobalt Blue
add Titanium White for highlights

Fig.39 GLASS AND TANKARD IN WATERCOLOUR

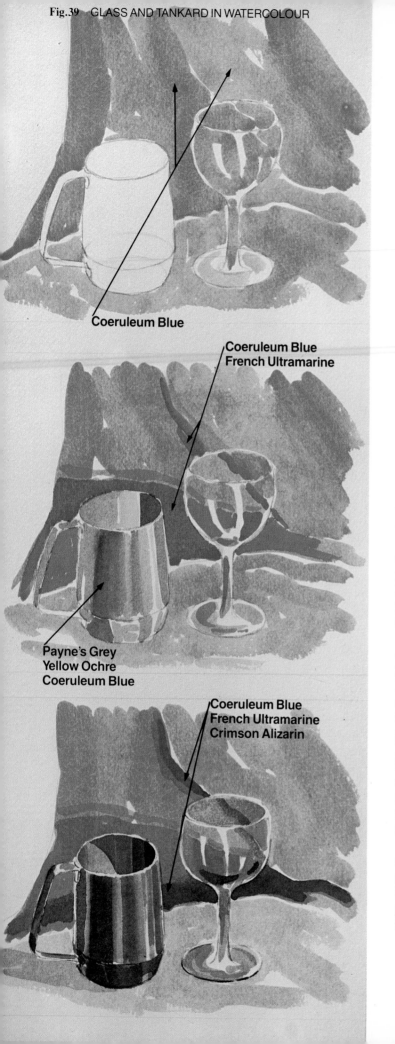

Coeruleum Blue

Coeruleum Blue
French Ultramarine

Payne's Grey
Yellow Ochre
Coeruleum Blue

Coeruleum Blue
French Ultramarine
Crimson Alizarin

If you look at the first stage it shows this very clearly, even at this point it is apparent that it is a glass. In stage two the glass is even more distinct, because of the dark background against the light edges of the glass (light against dark), and it is finished in the third stage. I worked in watercolour on Whatman 400 gsm, Not surface paper and I used a no. 10 and a no. 6 sable brush. The colours were Coeruleum Blue, Payne's Grey, Yellow Ochre, French Ultramarine and Crimson Alizarin. Draw the picture first with an HB pencil and then with your no. 10 sable, and plenty of water mixed with Coeruleum Blue, paint in the background.

In the second stage, paint in the tankard using Payne's Grey, Yellow Ochre and Coeruleum Blue; also paint in the dark shadow of the background with Coeruleum Blue and a little French Ultramarine. Stage three is really a repetition of what you did in the second stage except making everything a little darker and crisper. Add a little Crimson Alizarin to the dark shadow colour for the background.

Pastel was used for the fourth exercise (**fig. 40**) on Ingres paper. The colours were Burnt Umber tint 6, Cadmium Red tint 4, Madder Brown tint 4, Cadmium Orange tint 1, Cool Grey tint 4, and Ivory Black. The background was painted in first, using Cadmium Red tint 4, and Madder Brown tint 4 for the shadows of the material. Paint the coffee pot in with Burnt Umber tint 6 and also the two colours used for the background. Use Cool Grey tint 4 for the highlights. In the final stage paint the bowl with the same colours as the coffee pot but using Cadmium Orange tint 1 for the inside, lighter area. Finally smudge the colours together with your fingers and add more highlights to the coffee pot and bowl with Cadmium Orange tint 1.

For the last exercise, I used Cryla Flow Formula on an acrylic-primed board. The colours I used were Cadmium Yellow, Ultramarine, Crimson, Cadmium Red, Burnt Umber, and Bright Green. I used size nos. 2, 4 and 6 nylon brushes and a no. 6 sable. Draw the fruit in first with an HB pencil, then paint in the background. Work on the bananas next and then the apple. In the final stage don't let the grapes worry you. If you look closely at a bunch of grapes, or in particular at mine in the painting, you will see that each grape is made up of a 'middle' colour, then darker areas where they have cast shadows on to other grapes in the bunch, until finally each grape has a highlight or lighter area.

Paint the markings on the bananas. Notice the two shadows cast by the grapes on the right of the apple, and paint them in. Paint in the darker areas of the cloth background. This will help you to finish off your grapes, as it will define some of the edges. Finally put in some lighter areas on the material.

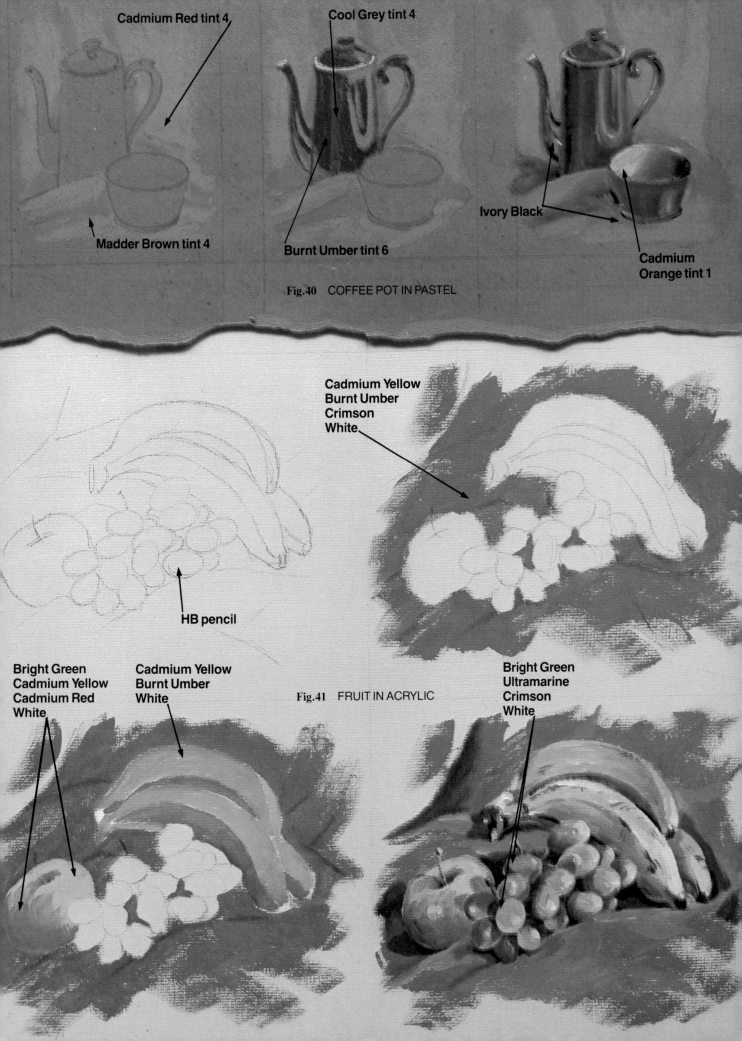

Cadmium Red tint 4

Cool Grey tint 4

Madder Brown tint 4

Burnt Umber tint 6

Ivory Black

Cadmium Orange tint 1

Fig.40 COFFEE POT IN PASTEL

Cadmium Yellow
Burnt Umber
Crimson
White

HB pencil

Bright Green
Cadmium Yellow
Cadmium Red
White

Cadmium Yellow
Burnt Umber
White

Fig.41 FRUIT IN ACRYLIC

Bright Green
Ultramarine
Crimson
White

DIFFERENT MEDIUMS FOR THE SAME SUBJECT

I thought it would be useful to show you the same still life painted in different mediums so you can compare the results. They were all done the same size: 25 × 38 cm (10 × 15 in). The pastel was on brown Ingres paper, the watercolour on Whatman 400 gsm Rough surface, and the oil and acrylic on primed painting board.

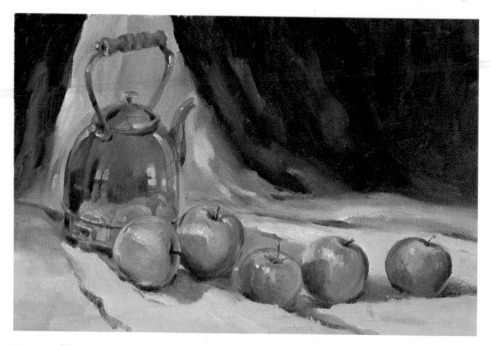

Fig. 42 Oil

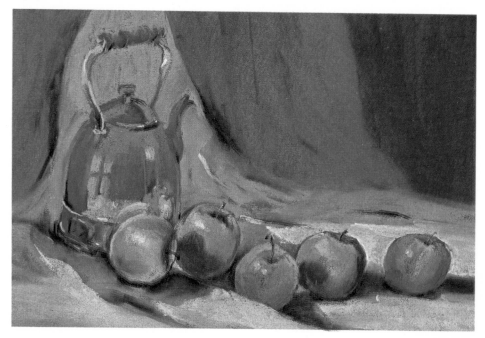

Fig. 43 Pastel

What is most apparent to me, is the similarity between the one painted in oil and the one in acrylic. Apart from the acrylic painting having an overall pink look to the white areas (perhaps I used more Crimson in this one) and the oil painting having a yellowish hue over the same areas, the paintings are very much the same. The watercolour, with its light areas of white paper showing through the material, has a lovely freshness that I believe all watercolours should have. I thoroughly enjoyed working on the pastel painting and was surprised at how much feeling I could get out of the colour and reflections in the copper kettle using this medium. If you can paint in more than one medium have a go, you will learn a lot and enjoy it at the same time.

One final observation – I am not sure whether the first red apple and the third green one cross over each other enough. I think it would have been more successful if the red apple had hidden the green one more, rather than creating a space between them. In painting, remember, you either hit or miss (see page 33). What do you think?

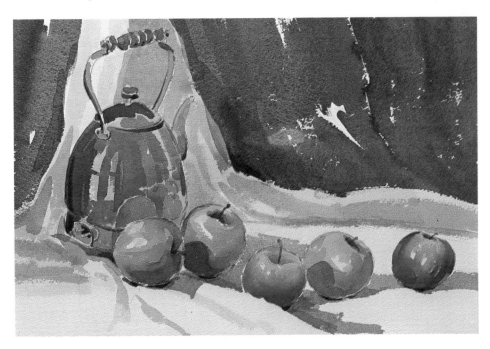

Fig. 44 Watercolour

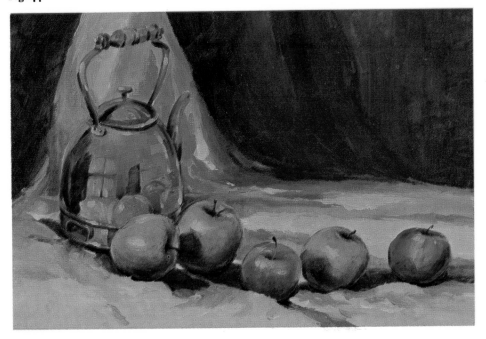

Fig. 45 Acrylic

EXERCISE ONE
Daffodils in watercolour

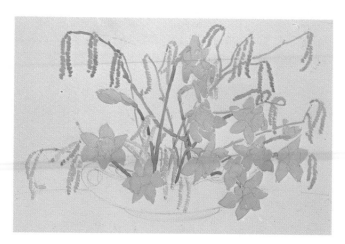

Fig. 46 First stage

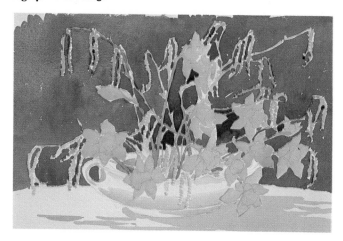

Fig. 47 Second stage

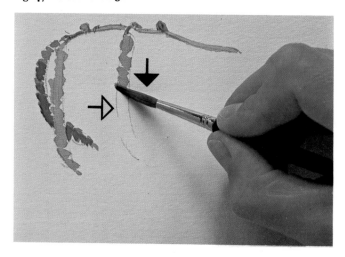

Fig. 48 See key for arrows in **fig. 22**

For your first exercise I have chosen to do a watercolour painting of daffodils. In this exercise and those which follow, it is important when mixing a colour to start with the one I have listed first, *then* add the other colours to it, usually in smaller amounts. The first colour of your mix should be the main one. When white is used in oil or acrylic painting, it is usually used last unless, of course, white is the main colour. In these exercises I have tried to give you a detailed account of how I have worked. Naturally, I do not have the space to discuss *every* brush stroke, but I have analysed the stages of the painting, and explained its most important features.

When I stopped for each stage, it was photographed, and then I continued painting. This method enables you to see the same painting as it develops, and you can compare each stage with the one that has gone before. The actual size of each painting is indicated next to the finished stage as it is important for you to have an idea of the scale to work to. The close-up illustrations are reproduced the same size as I painted them so you can see some of the brush strokes. I have also illustrated the method I used for certain parts of the paintings if I thought you would need to see them more closely.

I have painted these subjects in my own style which has evolved over the years. The way I paint in this book is the way I work; I haven't made the paintings work for the book. We all have a creative style of our own and this will emerge naturally. Once you have mastered a medium, *let your own style come to the fore.*

First stage I used Whatman watercolour paper 400 gsm Not surface. First draw in the outline with an HB pencil. Then with your no. 10 sable brush paint in the daffodils using Cadmium Yellow Pale and plenty of water. Mix a little Crimson Alizarin and French Ultramarine to your wash and add it to the shadowy side of some of the daffodils while they are still wet. Next use your no. 6 sable brush and paint in the catkins. Paint from the top of each catkin downwards. Blob your brush on to the paper to give the catkin its rounded shape, using Cadmium Yellow Pale, Crimson Alizarin, French Ultramarine and a slight touch of Hooker's Green No. 1. Keep your paint very wet. Using the same colours, only a little greener, paint in the catkins' twigs. With the same brush mix Hooker's Green No. 1, Cadmium Yellow Pale and a little Crim-

42

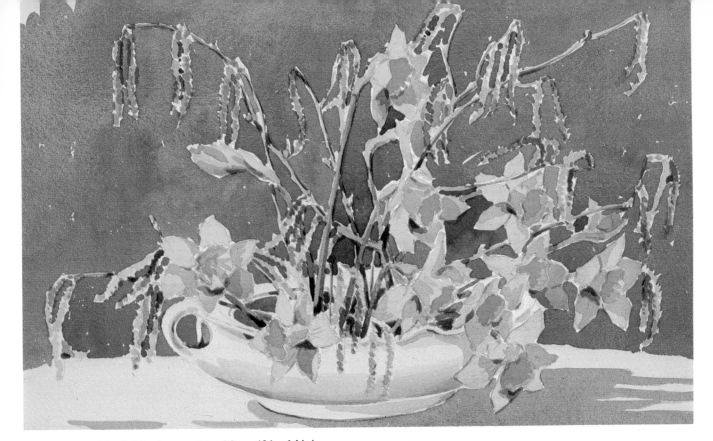

Fig. 49 Daffodils, finished stage, 24 × 36 cm (9½ × 14 in)

son Alizarin, and paint in the daffodil stalks. At the end of each stalk add some of the catkin colour, taking it right up to the flower head.

Second stage Use your no. 10 sable brush and mix a watery wash of French Ultramarine, Crimson Alizarin and a touch of Yellow Ochre to paint shadows on the bowl. When this is dry use a very wet wash of French Ultramarine, Crimson Alizarin and a small amount of Yellow Ochre for the darker areas, then paint in the background. Use your no. 6 brush for working in between the stalks if you find it necessary. Work freely from top to bottom leaving crisp accents of white paper against the yellow of the petals, stalks and catkins. Now using the same colours as you used for the bowl, paint in the shadows on the table with your no. 10 sable.

Finished stage Let your no. 6 sable brush work over the daffodils with a wash of Cadmium Yellow Pale and Crimson Alizarin, then paint in the deeper yellow of the daffodils' trumpets. Add a touch of French Ultramarine and Hooker's Green No. 1 to your wash and paint in the shadows on the petals. With the same wash paint inside the daffodils' trumpets again. When this is dry, still using the same wash, paint over some of the shadows on the petals to vary the tone and colour. Now taking the catkins' colour, only darker (to achieve this add more pigment), use the same blobbing technique with your no. 6 sable and darken some of the catkins. Finally add dark accents to the twigs, stalks and bowl, and wherever you think it is needed to

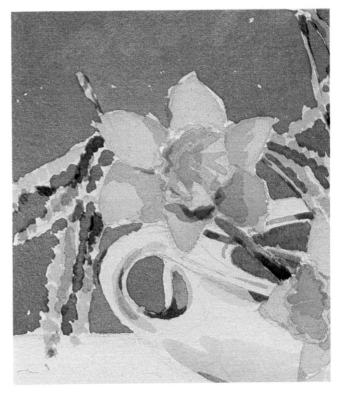

Fig. 50 Detail from finished stage

make *your* painting a success.

I wasn't happy with the tone of the shadows on the table, I wanted it to be darker, so I put on another wash of the same colour to strengthen it. When *you* put your wash in at the second stage, try to get the tone right the first time if you can – not later as I did it.

43

EXERCISE TWO
Vegetables in basket in oil

In this exercise, and exercises four and six, I have illustrated the main colours used to guide you. They are both primary and mixed colours. For this exercise, as in all my oil paintings, I did not use a palette knife to mix the paint but the same brush I painted on the canvas with. I used a gel medium to mix with the paint to speed up the drying process. When I wanted to thin the paint, I added turpentine. I also had a separate holder full of turpentine for washing out my brushes.

I chose a basket with vegetables, because they are a traditional still-life subject and I enjoy painting them – I hope you do too. I painted on a ready-primed canvas.

First stage Draw in the picture with an HB pencil. Then with a no. 10 bristle brush and a mix of Burnt

Fig.51

VEGETABLES

Viridian
Cadmium Yellow
Burnt Umber
Cobalt Blue
Titanium White

BASKET

Yellow Ochre
Titanium White
Crimson Alizarin
Cobalt Blue
Burnt Umber

TABLE

Titanium White
Yellow Ochre
Cadmium Yellow
Crimson Alizarin
Cobalt Blue

Umber, Yellow Ochre and a touch of Cobalt Blue paint in the background working from top to bottom. Next insert the dark areas of the basket which represent the spaces in between the weave, using your no. 8 bristle brush with a mix of Cobalt Blue, Crimson Alizarin and a touch of Burnt Umber.

Second stage Throughout this stage use a no. 4 bristle brush. Carry out the initial painting of the vegetables now. I like to paint as directly as possible, so I try to obtain the desired effect straightaway. Naturally, this is not always possible, but if you work with that in mind, your chances of having a fresh and unlaboured painting are good. It will also avoid an oil painting becoming muddy looking from overworking areas that are still wet.

Start to paint the cauliflower leaves with a mix of Viridian, Titanium White, Cadmium Yellow, and a touch of Burnt Umber and Cobalt Blue for the dark areas. Put in the leeks using the same colours. Since they look whiter at the root add much more Titanium White to your colour, and as you work up the leaves, add more Cadmium Yellow into the green; use this colour for the flat end of the leeks as well. Find a dark mix of colour on your palette. (Throughout the duration of a painting there are many mixtures of colour on a palette. Use them and never remove them unless you want a clean area on which to mix a fresh colour.) Draw in the main contours that break up the cauliflower and give it its shape. These will guide you as you fill it in. Paint in the areas of shadow first with a mix of Cobalt Blue, Crimson Alizarin, a touch of Yellow Ochre and Titanium White, allowing some of the guidelines to show through. Then paint in the light areas using much thicker paint consisting of Titanium White, Yellow Ochre and some Burnt Umber. Pick up from the palette mixtures of colour that can help you with the moulding of the cauliflower.

Paint in the parsnips using Yellow Ochre, Burnt Umber, a little Crimson Alizarin and Titanium White. Work the brush in round movements following the round shape of the parsnips, which will help to suggest their form. Add the two mushrooms, putting in the caps and stalks in Cobalt Blue, Crimson Alizarin, Yellow Ochre and Titanium White, and do the dark gills in the same colours, only much darker (using less Titanium White). When you paint the underside of the mushrooms, let the brush follow the direction of the

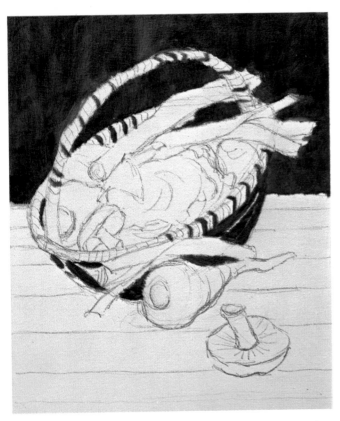

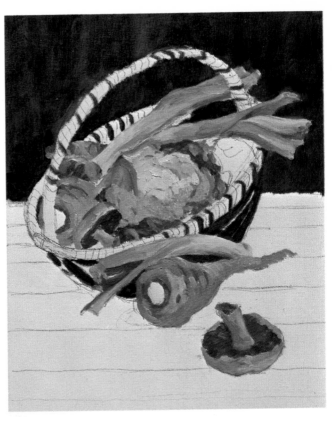

gills, and it will indicate their form as the brush strokes did for the parsnips. Always remember that a brush stroke is very descriptive, and if used to its full advantage has a tremendous influence on a painting.

Fig. 52 First stage (*above left*)
Fig. 53 Second stage (*above*)
Fig. 54 Third stage (*below*)

Third stage Before you begin the basket, work in the potato using Yellow Ochre, a touch of Crimson, Burnt Umber and Titanium White. When you add the dark blemishes, and also where the potato goes into dark shadow, put a little Cobalt Blue with your colour to darken it. Next paint the ends of the parsnip using Burnt Umber, Cobalt Blue and Viridian with Cadmium Yellow. Don't mix it thoroughly on the palette. Do this on the canvas by pushing the paint on to give it a rough, broken-off texture.

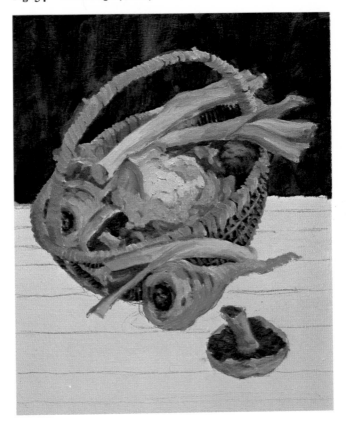

Still using your no. 4 bristle brush start the basket using Yellow Ochre, Titanium White, a touch of Crimson, Cobalt Blue and a touch of Burnt Umber. Keep the paint changing tone and colour all the time. Don't mix it all up on the palette into one uniform colour or your basket will look flat and uninteresting. This is a very important area where the brush strokes show form. As you paint imagine that each brush stroke is a piece of cane being woven into the basket. By doing this your basket will have a feel of the real thing about it. If you do this I think you will be surprised at the results.

Finished stage Draw in the shape of the shadows with a pencil. Then with a no. 6 sable brush add dark colour

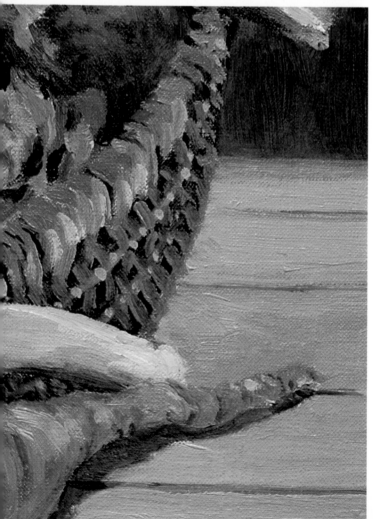

in horizontal lines to represent the joins in between the wooden slats of the table. Use your no. 8 bristle brush now, and with a mix of Titanium White, Yellow Ochre, a touch of Cadmium Yellow and Crimson Alizarin, work on the table from the top right-hand side of the basket (the lighter side) in horizontal brush strokes.

Next work on the left-hand side of the basket adding a little Cobalt Blue to darken the colour, and continue until the table is finished. Leave the shadow areas unpainted. Using a mix of Cobalt Blue, Crimson Alizarin and a touch of Yellow Ochre, paint in the shadows and merge them slightly around the edges into the wet colour of the table. Paint over the lines of the slats to give them more definition and paint them darker across the shadows. Finally work over the whole painting, putting in dark accents and highlights to give it form and detail.

How much detail you put in is up to you. Leave the painting for a couple of days and look at it again with a fresh eye. There will be passages of the painting that you will see differently, and you can alter or keep them accordingly.

Figs. 55 (*Left*) and **56** (*below left*) details from finished stage
Fig. 59 (*Right*) Vegetables in basket, finished stage, 41 × 30 cm (16 × 12 in)

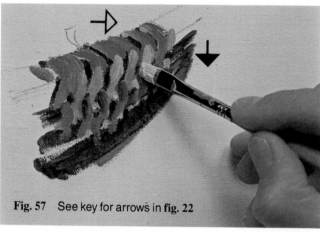

Fig. 57 See key for arrows in **fig. 22**

Fig. 58

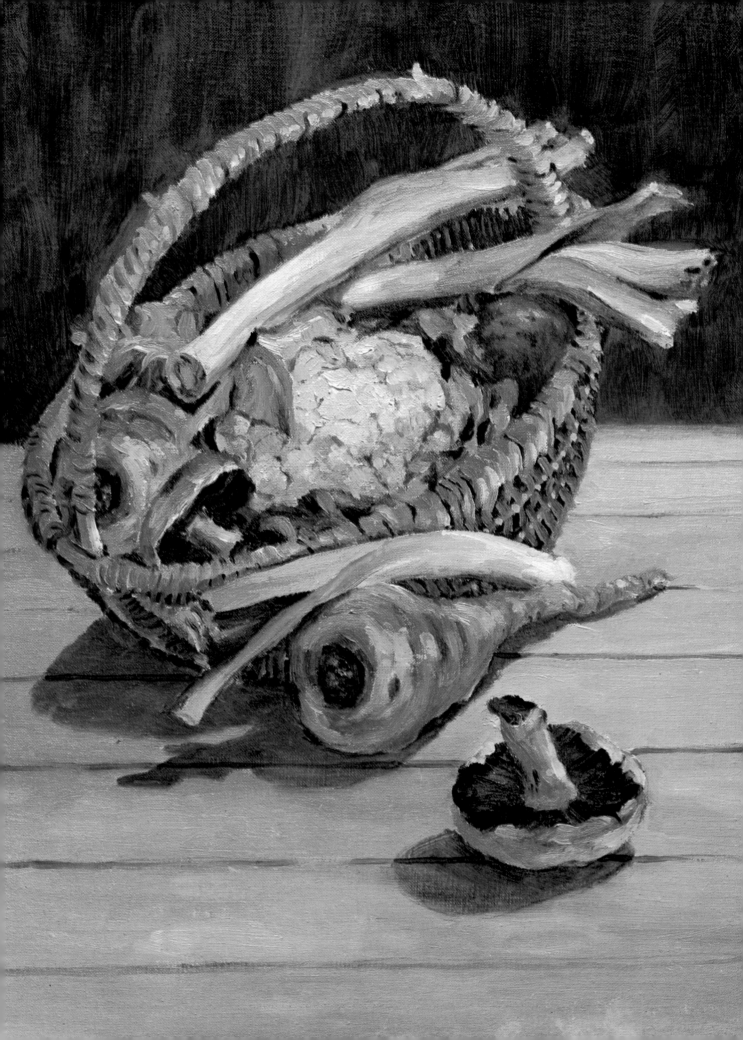

EXERCISE THREE
Melon, flour bin and apple in pastel

I enjoyed painting this exercise. I set out to look for shapes and made a satisfying design with a melon, a flour bin and an apple: three simple objects against a neutral background, and what a time I had arranging them! You will find that the simpler the still life is, the longer it takes to set up. I think that is because when there are so few objects, each one takes on special importance. You will notice that I have left a lot of paper unpainted for the background. This seemed to me to be in sympathy with the simple design, and the colour of the background also helped to hold the picture together. I worked on Ingres paper.

First stage Draw the still life onto the paper with a 2B pencil. Then paint in the flour bin using Yellow Ochre tint 4, Burnt Sienna tint 4 and Yellow Ochre tint 2. Paint the inside of the bin first with Burnt Sienna tint

Fig. 60 Detail from finished stage

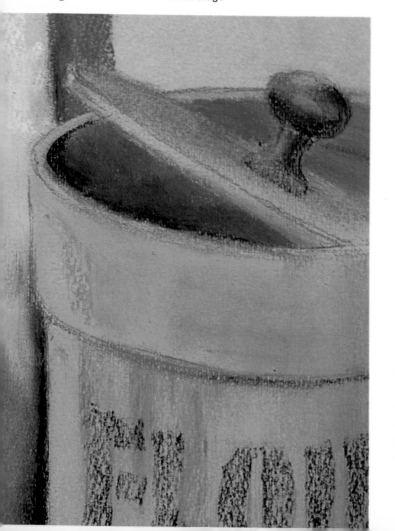

4, then over the top paint Yellow Ochre tint 4. Smudge these colours together with your finger, and smudge over the lid. On the shadow side paint over with Vandyke Brown tint 4 and smudge it in. Hold your pastel flat, see **fig. 64**, and using Yellow Ochre tint 4 work down the outside of the bin. Add Burnt Sienna tint 4 over this, still holding the pastel flat, then rub it in gently with your finger (see **fig. 65**). Now add Vandyke Brown tint 4 on the right-hand side of the bin and paint some Ivory Black on the inside on the shadow side.

Second stage Paint the cloth on the left-hand side of the flour bin by putting in the shadow with Cool Grey tint 4. Then using Olive Green tint 0 to paint in the light areas, smudge it in as you work. Use Yellow Ochre tint 0 to put in some highlights, then with Ivory Black paint the dark shadow to the left of the flour bin. Carefully put a piece of thin paper on the flour bin close to the edge, and work the pastel up to it. Then smudge with your finger *away* from the paper edge (flour-bin edge). You will get a good clean edge to the bin.

With Hooker's Green tint 5 start painting the melon. Draw around the top edge of the melon and then work in the rest of the skin area – do this for both pieces. Now on the 'cut' surface, from the dark green edge you have just drawn in, work Lizard Green tint 8 inwards towards the seeds, and using Lemon Yellow tint 4, carry on into the seed area. Then work in some Cadmium Red tint 4 (from the seed area outwards) and *gently* smudge it all together. With single strokes paint in highlights on the seeds using Cadmium Red Orange tint 3, and work Vandyke Brown tint 8 into the dark green of the skin to darken it, leaving some green showing to suggest reflected light.

When you are working don't worry about the pastel colours going over onto other colours, it can often enhance the painting. If you do paint over an edge that you want to keep, then either brush the pastel out with a paint brush: bristle, nylon or sable according to how much pressure is needed, or lift the pastel off with a kneadable putty rubber.

Third stage Shade in the darker side of the melon seeds, first with Cadmium Red Orange tint 3, then over the top paint in Vandyke Brown tint 4 working in more dark into the bottom corner, rubbing it in with your finger. Still using Vandyke Brown tint 4, draw in some of the seeds to give that area shape. Do this for both

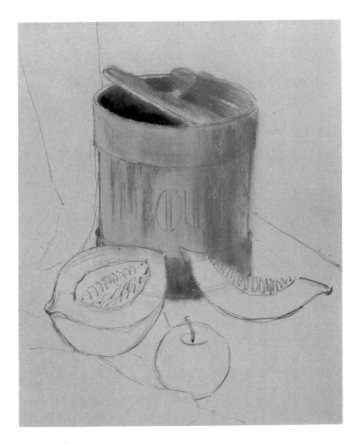

Fig. 61 First stage

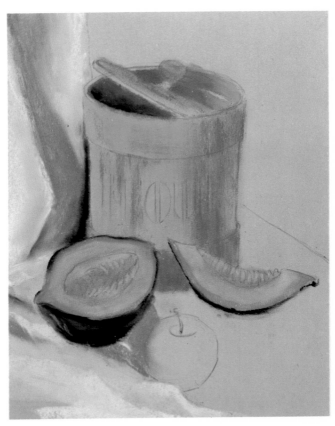

Fig. 62 Second stage

pieces of melon. The work must be delicately carried out or the melon will look heavy and out of character. Add highlights to all of this area using quick sharp strokes of Lemon Yellow tint 4. Incidentally the colouring of the cut melon was changing rapidly the whole time I was working. Remember this when you paint one from life.

Next work on the apple. Start by working Yellow Ochre tint 4 from the top of the apple downwards into where the red will be. Add to that just a little Lizard Green tint 8. Now work down with Cadmium Red tint 4. Rub in the colours and finally paint over the dark red areas with Crimson Lake tint 6, carry on rubbing in and painting until you get the colours and tone you require. With Vandyke Brown tint 4 paint in the shadow area at the top where the stalk grows and smudge it in. Also add a highlight in Yellow Ochre tint 4 on the top of the apple. Put in the shadow cast by the cloth behind the flour bin with Vandyke Brown tint 4 and work Cool Grey tint 4 on top, then rub it together. Now work in the shadow to the right and the bottom of the bin, and under the melon and apple with Cool Grey tint 4. Where the shadow cast by the bin goes up the wall, add Vandyke Brown tint 4 over and outwards.

Finished stage As usual this stage is the tidying up point, when we add dark and light accents to give the painting depth. Notice how I cleaned up the area

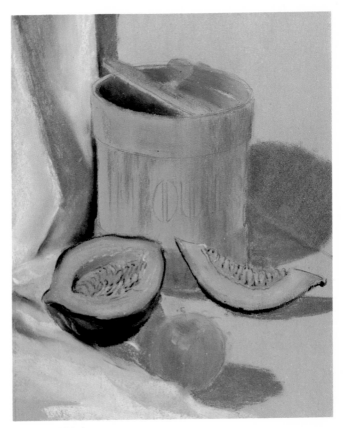

Fig. 63 Third stage

49

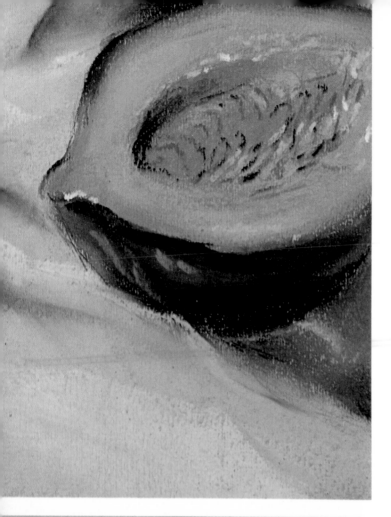

around the apple with a putty rubber where the pastel had strayed onto the background. On the flour bin use Vandyke Brown tint 8 for the dark accents, and Yellow Ochre tint 2 for the highlights. Where the shadows start under the fruit, paint just a little Ivory Black and smudge it in. Add more Crimson Lake tint 6 to the apple, in definite curved strokes. Paint the apple stalk in Ivory Black, and its shadow in Cool Grey tint 4. Find an Ivory Black piece of pastel the width of the lettering and using very little pressure work in down strokes to put in the word, FLOUR. Finally using Ivory Black for the dark accents, and Silver White or Yellow Ochre tint 0 for the light accents, work over the painting adding these wherever you think they are needed.

Remember that when you use pastel, the pastel stroke, as with your brush stroke, is very important to create the form of what you are painting. The way you rub or smudge it in with your fingers is just as important as the way you apply each brush stroke. Your brush strokes, pastel strokes and finger strokes should follow either the direction of growth of an object, the direction of movement of an object, or its contours.

Figs. 64 (*Left*) and **65** (*below left*) details from finished stage
Fig. 68 (*Right*) Melon, flour bin and apple, finished stage, 34 × 27 cm (13½ × 10½ in)

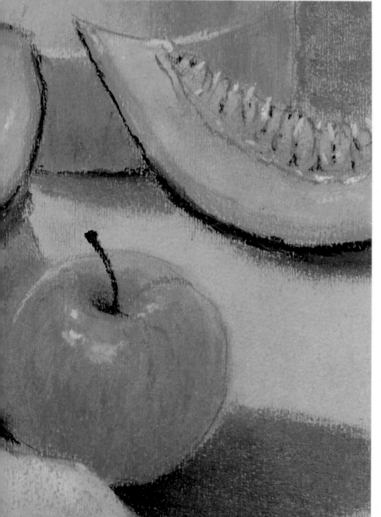

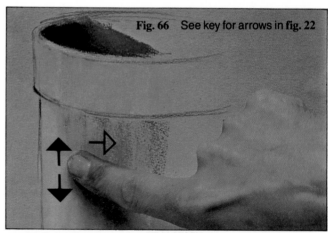

Fig. 66 See key for arrows in fig. 22

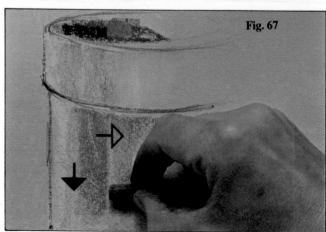

Fig. 67

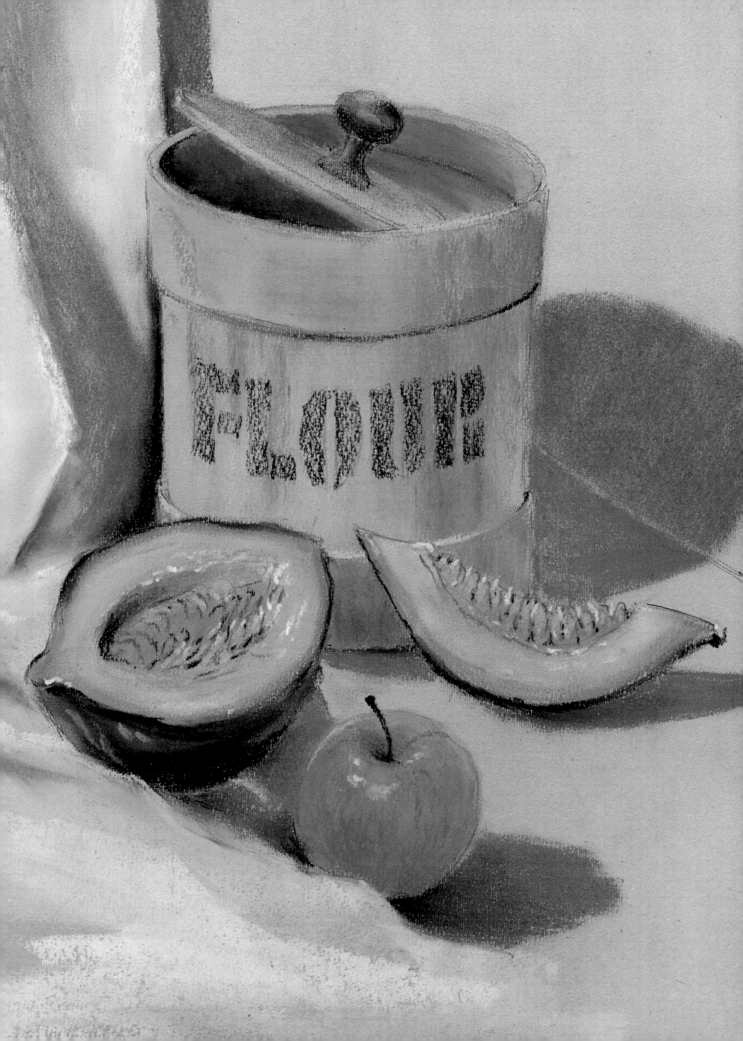

EXERCISE FOUR
Leaves in teapot in acrylic

This still life has the warm reds and golds of autumn, and in contrast, the white and blue of the teapot. I painted this in acrylics, but if you feel like having a go in any other medium then try it. Naturally there will be certain things you can't imitate exactly if you do choose another medium, but you will see how I painted it. In any case if you use another medium it will be a good lesson for you. I painted this exercise on acrylic-primed canvas.

First stage Draw the picture with your HB pencil. Then with your no. 6 nylon brush and a mix of Raw Sienna, Burnt Umber and Crimson work from the top to the bottom using the paint thinly to let your drawing show through. Work your brush in different directions and paint darker areas where the folds appear. Use a little Ultramarine with your mix for these darker areas.

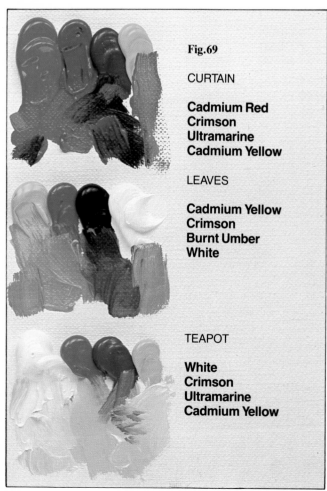

Fig.69

CURTAIN

Cadmium Red
Crimson
Ultramarine
Cadmium Yellow

LEAVES

Cadmium Yellow
Crimson
Burnt Umber
White

TEAPOT

White
Crimson
Ultramarine
Cadmium Yellow

Add lighter areas to the background with a mix of Raw Sienna and White. Now work the cloth on the table, using more Raw Sienna with your colours and White. This time let your brush strokes follow the flatness of the material. For the moment leave the leaves unpainted, but don't try to keep to the pencil edge, it doesn't matter if you overlap into the leaf area.

Second stage Paint in the red crushed velvet from top to bottom using the same brush, no. 6, with Cadmium Red and Cadmium Yellow. Work your brush strokes in all directions and use the paint thinly to represent the light areas of velvet. When this is dry, mix Cadmium Red, Crimson and Ultramarine, and again with the brush strokes working in different directions, paint in the darker reds. When this is dry, mix a wet dark mixture of Crimson and Ultramarine to paint the shadows cast from the folds. Since this is painted on very wet, it is like watercolour, and will show through the darks and lights of the cloth underneath, giving the impression of shadows. It has been painted in this way to give an effect of crushed velvet. It is simply a technique, but if you find a different method to get the result you want, then go ahead – it could be better than mine!

Now paint the background to the left of the material using Raw Sienna and a little Raw Umber with your no. 6 nylon brush. Next paint the teapot with a mix of White, a little Crimson, Ultramarine and a touch of Cadmium Yellow, using a no. 4 nylon brush. Paint the shadow side first, using less White, then do the lighter side. Don't forget to paint in the shadow of the handle on the surface of the teapot to show off its contour. The dark area inside is painted from the same colours but with only a touch of White.

Third stage Paint the twigs using your no. 6 sable and a mix of Burnt Umber and Ultramarine with a touch of Bright Green. As you paint work the brush in the direction of growth of the twigs. This is important to maintain the natural feeling of growth. Next paint in the leaves. It is not possible to explain how every leaf was painted. I can only tell you how I painted them in general and you can follow the picture for stage three to see which leaves were painted dark or light. Look at stage two again and you will see that the extreme left-hand leaf has some red from the curtain daubed on it. I did this when I painted the curtain material, so that

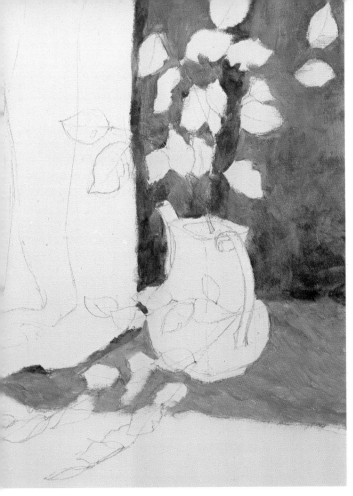

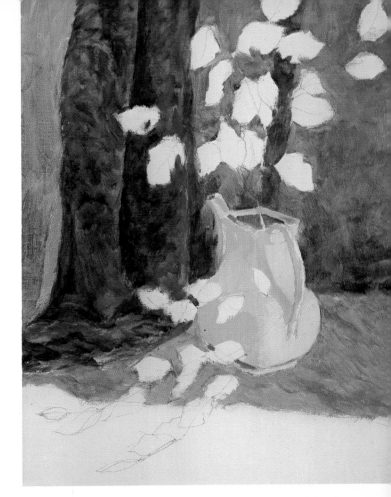

the leaf could be painted with a hole through it. The leaf directly underneath has a very irregular shape, showing where an insect has eaten the leaf away. Use your no. 6 sable with a variation of colours mixed from Cadmium Yellow, Crimson and Burnt Umber. Mix your paint with plenty of water and apply it in such a way as to get a watercolour effect. The white ground of the canvas will help with this, as the paint will be transparent in places.

Work from the base of a leaf, painting from the centre outwards on each side up to the point of the leaf. This indicates the veins. Where you want highlights on the leaves or to make the paint more opaque, add a little White with your colour. Still using your no. 6 sable with wet colours – Ultramarine, Crimson and a touch of Burnt Umber – paint the background behind the leaves a little darker, especially in the folds of the material. At this stage if you think that the red of the velvet is a little too bright, put a watery wash of Ultramarine and Crimson over parts of the curtain. Don't cover all the light areas or you will lose the velvety look.

Finished stage With your no. 6 sable brush wash over the background to the left of the red curtain using Ultramarine, Crimson and a touch of Raw Umber, getting darker towards the bottom. Paint in the blue pattern on the teapot with a wet mix of Ultramarine and a little touch of Burnt Umber in places, and using your no. 6 sable brush, *draw* the pattern on, starting

Fig. 70 First stage (*above left*) **Fig. 71** Second stage (*above*)
Fig. 72 Third stage (*below*)

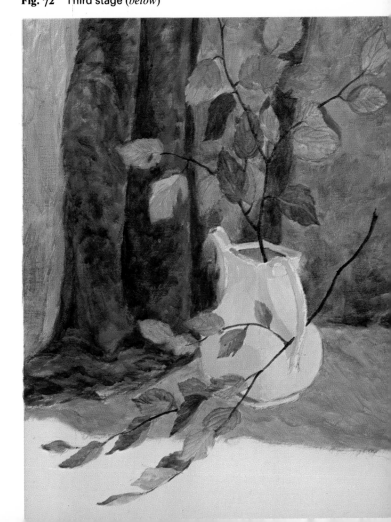

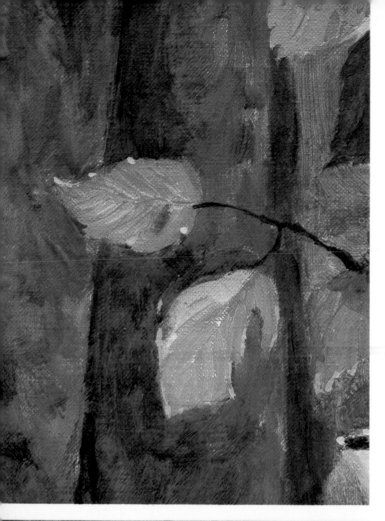

from the top on the left-hand side and working down. Make the paint less blue by adding more brown in the shadow areas. Do this painting with a watercolour treatment, see **fig. 73**. Next using your original colours, darken the shadows on the teapot, in particular the shadow of the handle, making it much darker at the handle's join. Also paint a shadow at the bottom of the pot under the handle with your no. 6 sable, and paint the shadow which is cast by the twig. Now with the same brush and dark paint, add accents to the teapot, in particular at the opening of the spout and inside the top.

Clean up the edges of the teapot and highlight it with White, a little Cadmium Yellow and a little Crimson. Paint in the shadow on the material in Ultramarine, Crimson and a little Burnt Umber with your no. 6 sable brush, and keep it wet. Paint the foreground table next, using a mix of White, Ultramarine, Crimson, a touch of Cadmium Yellow and your no. 6 nylon brush. When this is dry use the same colours with hardly any White, and with your no. 6 sable paint in the shadows cast by the material onto the table, and the shadows cast by the leaves. Put highlights on the twigs with a no. 6 sable and look over your painting, adding light and dark accents where necessary, plus any other finishing touches you want to insert.

Figs. 73 (*Above left*) and **74** (*left*) details from finished stage
Fig. 76 (*Right*) Leaves in teapot, finished stage,
41 × 30 cm (16 × 12 in)

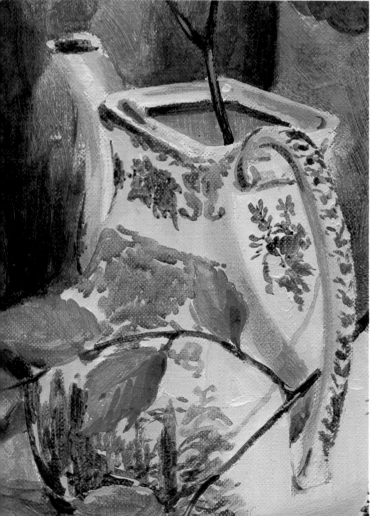

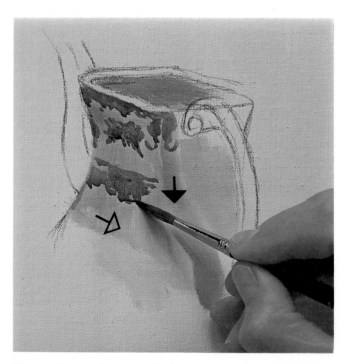

Fig. 75 See key for arrows in **fig. 22**

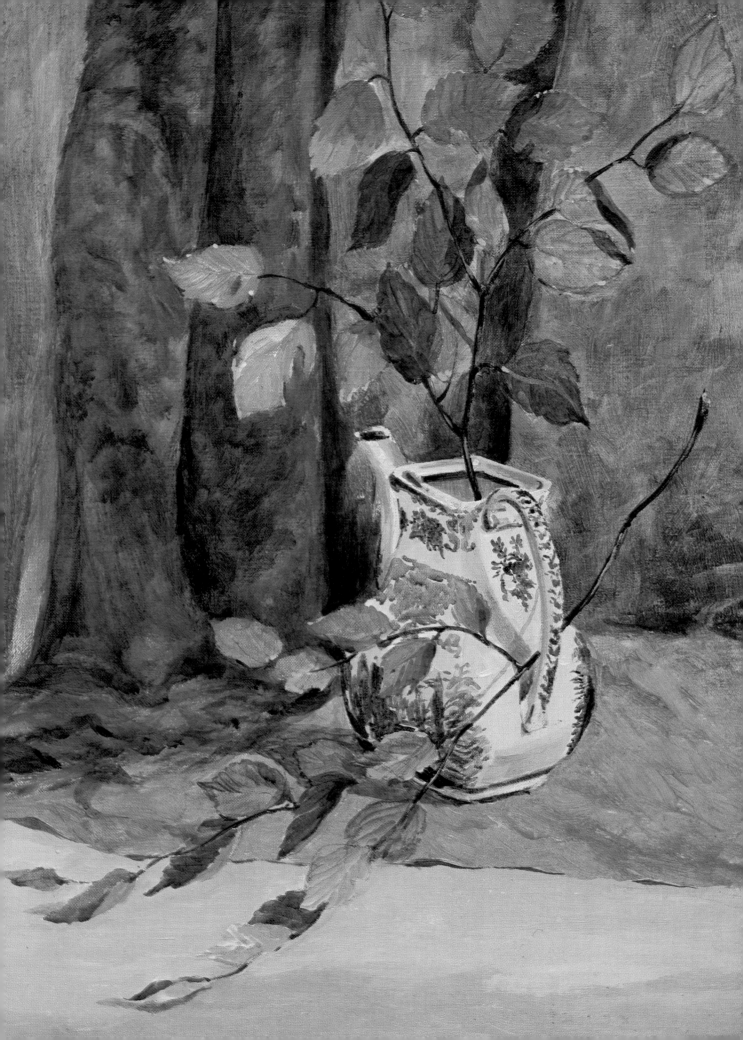

EXERCISE FIVE
Wellingtons in watercolour

This is the type of still life I discussed earlier in the book which has minimal control; the subject is out of doors and you must accept whatever changes occur in your environment. Unfortunately in this case, I had to work inside because of the photographer. I couldn't wait for the sun to come out, which was a good thing as it didn't appear for three days! However, I did the next best thing: I literally brought the outside indoors, and set it up in my studio. There were dirt and stones everywhere, but still it was worth it. I thoroughly enjoyed painting it, and I am sure you will too – good luck!

First stage I painted it on Whatman watercolour paper 400 gsm Not surface. I didn't stretch the paper, but just pinned it down onto a drawing board. Draw the picture with a 2B pencil. Don't worry if you think you have done too much drawing for a watercolour – I never worry about that. Even if you have overworked the drawing, you can always lift off the pencil marks with a putty rubber before you paint that area. However, in some cases, the pencil showing through a clean wash adds character to a painting.

Second stage Paint a very light coloured wash over the wall, soil and stones, using a no. 10 sable with Coeruleum Blue, Crimson Alizarin and a touch of

Fig. 77 Detail from finished stage

Yellow Ochre. Leave some areas white as you paint, and also leave the boots, the fork and the plant pot. As you paint use a combination of wet-on-wet and dry-brush techniques. When this dries, paint in the garden fork with your no. 6 sable brush using Cadmium Red and a little touch of Crimson Alizarin. While that is still wet run into it a little of the wall colour down the fork prongs but stop before the ends and leave the paper to show through white.

Third stage Now paint in the plant pot with your no. 6 sable brush, using Cadmium Red, Yellow Ochre and a touch of French Ultramarine. Inside the pot start at the left-hand side gradually getting darker as you progress to the right. Outside the pot start on the right-hand side and make it darker as you move to the left. Be free with your paint and don't labour it. Remember that you can't copy mine exactly and that your paint will take its own direction. Next do the wellies. Paint these with your no. 10 sable brush, starting with the part that is turned over, and use a mix of Yellow Ochre, a touch of Crimson Alizarin and a touch of French Ultramarine. Leave the paper white on the top edge of the right-hand boot, then paint in the rest using Payne's Grey, Yellow Ochre and a touch of Crimson Alizarin. Start on the dark side and work into the light adding more water and a little more Yellow Ochre. Leave the paper white to highlight the toes. Also leave a white paper edge against the lower edge of the turnovers. Now paint in the fork handle in the same colour as the boot tops. With your no. 6 sable brush paint in the shadow areas of the boot turnovers, using the same colours, but darker. Soften them on the right-hand edges by adding water to make the paint thinner.

When the bottoms of the boots are dry paint in the dark shadows on the left side, using your no. 6 sable, with the same boot colour, only darker. With the same brush and the plant-pot colours, add more dark shadows to it.

Stage four In this stage you concentrate on the earth, but don't try to copy mine exactly, or you will get into a mess. Use your no. 10 sable brush and with a varied mix of Burnt Umber, Hooker's Green No. 1, Crimson Alizarin, Yellow Ochre and French Ultramarine paint the earth and stones. Leave some areas that are already there white and also leave some of the original wash. With your no. 6 sable paint the earth inside the plant

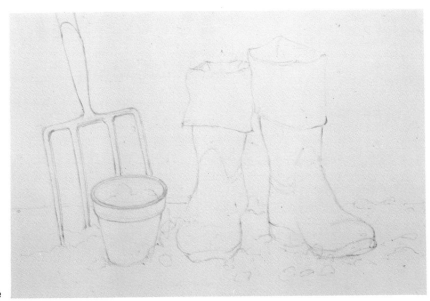

Fig. 78 First stage

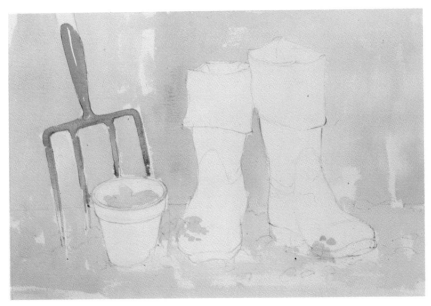

Fig. 79 Second stage

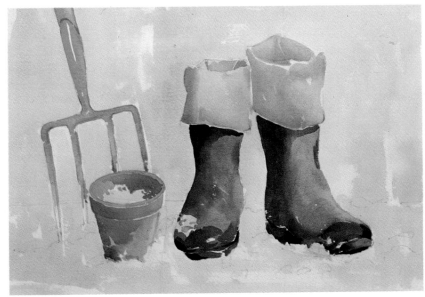

Fig. 80 Third stage

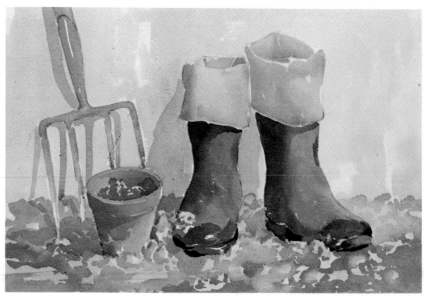

Fig. 81 Fourth stage

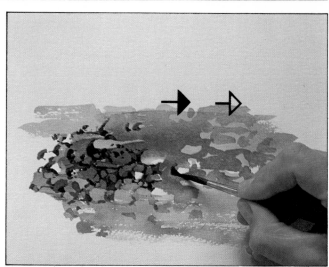

Fig. 82 See key for arrows in **fig. 22**

pot. When the earth is dry paint the shadows on the ground and up the wall behind. Use your no. 10 sable with a wash of French Ultramarine, Crimson Alizarin and a touch of Yellow Ochre and start the shadow of the fork at the top of the wall and work downwards. Work in the same way from the top of the boot down.

Finished stage This is where you finish the earth and stones. Look at **fig. 82**. I hope it will show you how to work on the stones. On the right, above and below my brush, is the stage you are at now. The light is coming from the right-hand side, so all the shadows are on the left of each stone. What I have done is to use the earth colours, only darker (although I am using the same mix I always change colour and tone very slightly as I work) and I painted the shadows of imaginary stones. I say 'imaginary' because it isn't practical to paint every one individually, but use them as a guide when you look at your own painting. If you look hard enough, you will see shapes left by your previous

washes that you can make into a stone just by adding a shadow, drawing it in with your brush. I did not know where my stones would be before I reached this stage. Use your no. 6 sable brush and have a go on your painting. If you are concerned because you have a fabulous painting so far and you think you might spoil it, then practise on another piece of paper. This method is also a help when you are painting foregrounds outside – it's well worth doing a dummy run.

When you have done that, it is time to sharpen up the painting where it needs it. Start by putting in a dark colour in the folds of the boot tops to show the creases. Then with the same colour, paint a shadow down the right-hand side of the left boot top. Add darker colour to the fork to crispen it up and put more dark shadow down the side of the plant pot.

As usual, look carefully at your painting to decide what you have to do. If you are uncertain, then leave it for a while and go back to it. You will see things you hadn't before with a fresher eye.

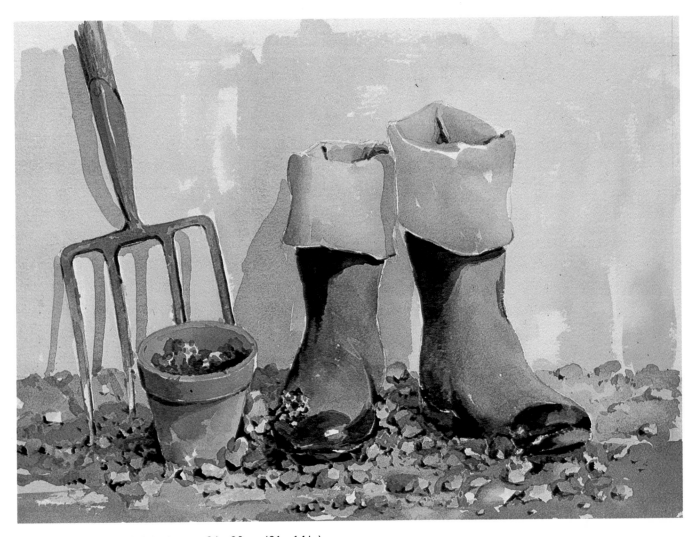

Fig. 83 Wellingtons, finished stage, 24 × 36 cm (9½ × 14 in)

Fig. 84 Detail from finished stage

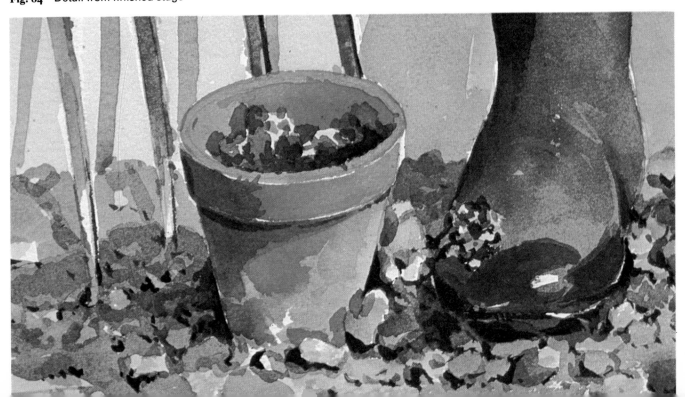

EXERCISE SIX
Lamp and blue duck in oil

I think that this is perhaps the most difficult of the paintings, because I have chosen an all-over pale background, with a light coloured lamp and glass against it. However, I am sure you will be able to cope with it by now if you have managed the other exercises. I worked this painting on oil-primed canvas, using my oil paint in exactly the same way as I did for the basket and vegetable exercise.

First stage Draw in the picture with an HB pencil. Then paint in the background wall using your no. 8 bristle brush with a mix of Titanium White, Yellow Ochre, a touch of Crimson Alizarin and a little Cobalt Blue. Begin painting at the top and work down, making the paint slightly darker as you go by adding small amounts of Cobalt Blue and Crimson Alizarin. Then paint inside the glass bowl of the lamp, leaving the canvas white where the highlights will appear later.

Make this colour darker than the background outside the bowl, and don't paint over the white material which shows through the glass.

Second stage Now paint the white cloth. The colours are the same as those you used for the wall behind but they are mixed in a different order. Look at the illustration of the second stage and you will see that the material is much cooler than the colour of the wall. When you mix start with Titanium White, a touch of Cobalt Blue, a little Crimson Alizarin and a touch of Yellow Ochre. With Cobalt Blue being mixed after the white the emphasis is on a cooler colour. Mix a light and darker colour (using less or more white). Then with your no. 8 bristle brush, paint the dark shadow areas first, and work the light coloured areas up and into them. Where the shadow is stronger, paint it in darker the first attempt. Where the material is draped over the table with the beads on it, add more Yellow Ochre to warm it up. The material picks a warm reflected light from the wall behind the duck. With the paint still wet blend the colours together wherever you feel it will improve the painting. Don't forget to paint the inside of the lamp's glass bowl, leaving the canvas unpainted where highlights will go. Make the paint a little darker than the background, where it is seen through the glass.

Third stage Now use your no. 6 bristle brush with the same colours as for the material, adding a little Viridian, and work on the lamp base. Don't put in the highlights until you have painted all of the lamp. Then mix Titanium White, Cadmium Yellow and a touch of Crimson Alizarin and paint in the highlights and the moulding (see **fig. 89**). If you feel a no. 6 brush is too large, then use a smaller one. Don't worry if your moulding at the base of the lamp is not exactly like mine. The important thing is to get the general feel of it.

Now paint in the lamp's brass fitting. The colours to use are Yellow Ochre, Cadmium Yellow, Crimson Alizarin, Cobalt Blue and a little Titanium White, but don't mix them evenly. Remember your light is coming from the right-hand side, so your darker colours (the shadows) will be on your left. Use your no. 4 bristle brush for this. Next, with the same brush paint in the frilly top of the glass bowl using the background colours which are reflected in the glass. Now we come to the duck. Mix Cobalt Blue and Viridian and a touch of Crimson Alizarin with the gel medium, but no white.

Fig.85

DUCK

French Ultramarine
Viridian
Crimson Alizarin
Titanium White

LAMP

Titanium White
Yellow Ochre
Cobalt Blue
Crimson Alizarin
Viridian

BRASS

Yellow Ochre
Cadmium Yellow
Crimson Alizarin
Cobalt Blue
Titanium White

This keeps the colours transparent. Start at the top of the head using the same brush, and follow the contours of the duck. Use mainly blue initially and work in your green as you come to the breast area.

Now add a little Titanium White where you want to lighten the colours. Work some of your brass colour outwards from the duck and down to its feet. Find some grey from your palette, and add a little Viridian, then paint the beak. It is important to have a palette which is large enough to mix all these colours, with room for your leftover mixtures. You can use these colours all through your painting. Now work in the base of the duck using the same brush (having cleaned it) and mix Burnt Umber, Crimson Alizarin, Ultramarine and a little Titanium White.

Finished stage Paint in the table with your no. 8 bristle brush and a mix of Titanium White, Cobalt Blue, Crimson Alizarin and a touch of Yellow Ochre. Use a dark mix first and paint in the shadows that are cast by the lamp and the material. Notice that I have made the shadow in the background, behind and to the left of the lamp, longer. This helped the composition I felt.

Fig. 86 First stage (*right*)
Fig. 87 Second stage (*below*)
Fig. 88 Third stage (*below right*)

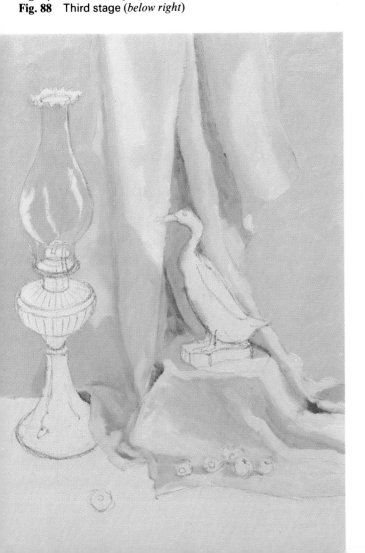

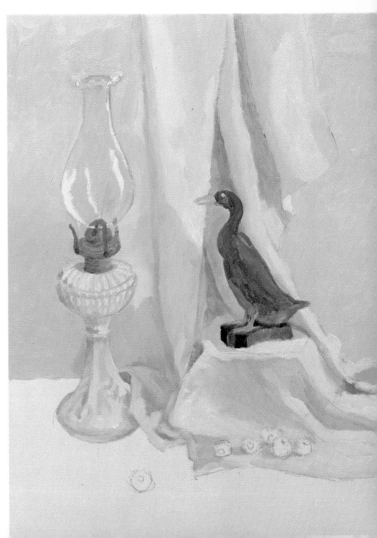

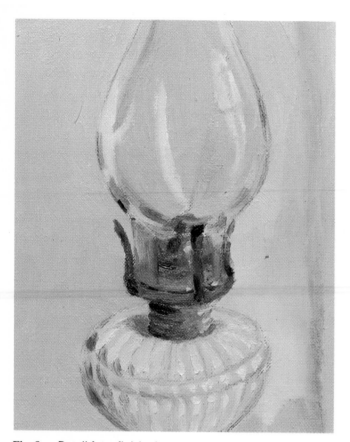

Fig. 89 Detail from finished stage

Fig. 93 (*Right*) Lamp and blue duck, finished stage,
41 × 36 cm (16 × 14 in)

Then paint in the white areas of the table. Now using a dark colour paint more dark shadows into the material folds, with your no. 4 bristle brush. Using the same brush paint in the dark areas on the frilly top of the glass bowl and inside. Still with the same brush, drag down and over the left side of the brass to do the glass. Do this also on the right side. Compare stage three with the final stage to see how I did this.

Now paint in the highlights on the glass using your no. 4 bristle brush, and with a pale grey mark in the lines on the right-hand side, which are highlights from the window frames of my studio. Still with the same brush and brass colour, put in the reflected colour on lower part of the glass. Next work some more darks and lights onto the base of the lamp, and with your no. 6 sable brush work on the duck, giving it more form. Now work on the beads using your no. 4 bristle, and a mix of Cobalt Blue and Titanium White – for the dark areas, add a little Crimson Alizarin. Use your no. 6 sable to paint in the holes and highlights on the beads. Put in the shadow on the table cast by the lone bead and, finally, put more highlights and dark accents wherever you feel they may be necessary. The highlights on the brass are made up from Cadmium Yellow with just a little Titanium White.

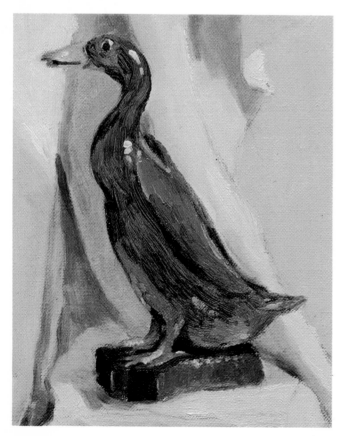

Fig. 90 Detail from finished stage

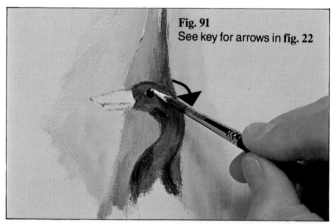

Fig. 91
See key for arrows in **fig. 22**

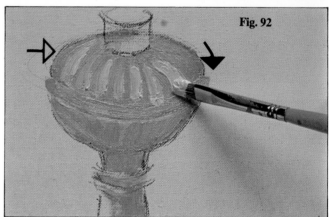

Fig. 92

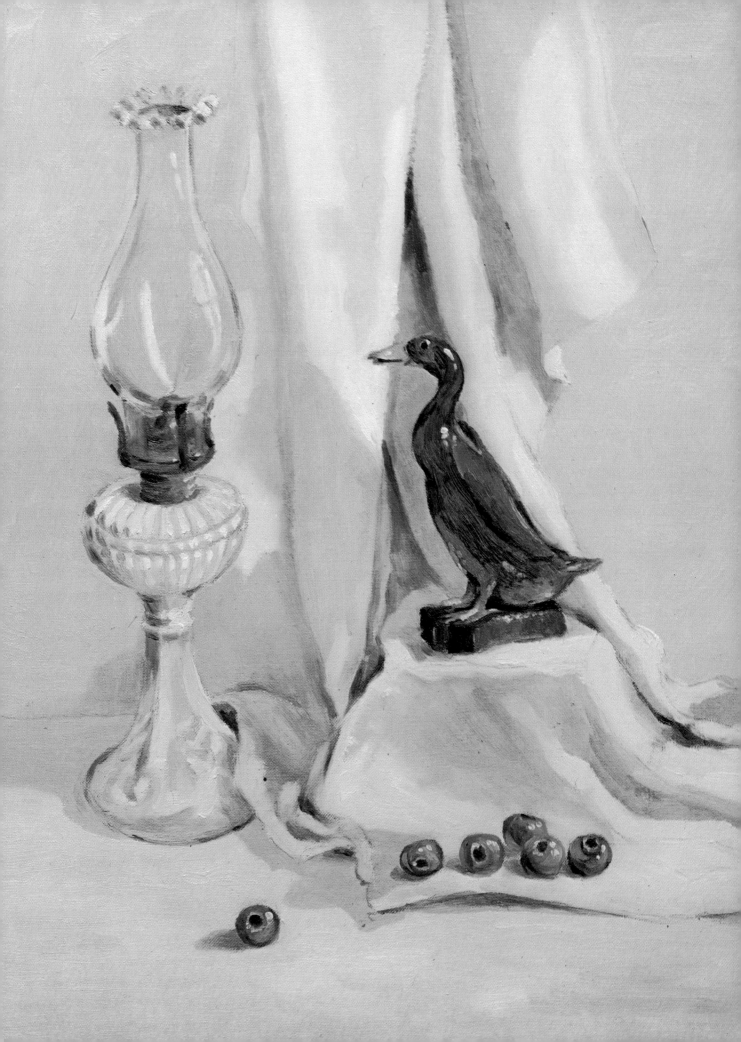

DO'S AND DON'TS

Always look carefully at your subject before you start

Buy the best materials you can afford

Don't attempt anything over-complicated to begin with

Paint subjects that inspire you

Don't spend too long setting up your still life – there may be no time left for painting!

Keep detail to a minimum while you are learning

Make sure you paint from a comfortable position

When mixing colours always start with the predominant one

Don't use acrylic paint over oil

Vary the amounts of colour used in a mixture

Observe – it is the key to good painting

Practise as often as possible

Enjoy your painting – remember that it is fun!

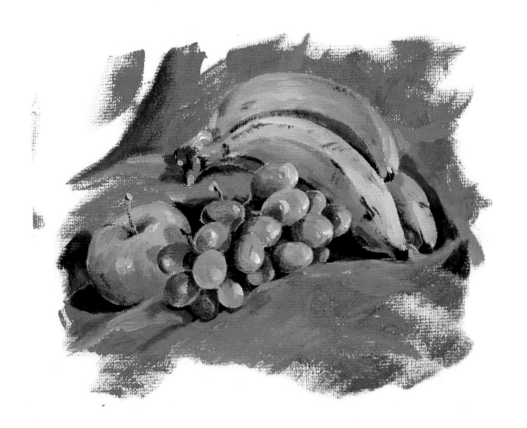